A VISUAL GUIDE
to CLASSICAL ART THEORY
for Drawing and Painting Students

Eric Mantle

PARKHURST BROTHERS, INC., PUBLISHERS

Parkhurst Brothers, Inc., Publishers

Little Rock, Arkansas

www.pbros.net

Parkhurst Brothers books are distributed to the trade through the University of Chicago Press Distribution Center. Copies of this and other Parkhurst Brothers Inc., Publishers titles are available to organizations and corporations for purchase in quantity by contacting Special Sales Department at our home office location, listed on our web site.

Printed in Canada

First Edition, 2009

12 11 10 9 8 7 6 5 4 3 2 1

Library of Congress Number: 2009922806

ISBN: 978-1-935166-12-2 [10 digit: 1-935166-12-3]

This book is printed on archival-quality paper that meets requirements of the American National Standard for Information Sciences, Permanence of Paper, Printed Library Materials, ANSI Z39.48-1984.

All illustrations used in this book are the property of the author or were secured for use in this book by the author.

Book and cover design:
WENDELL E. HALL & ERIC MANTLE

Page composition:
ERIC MANTLE & SHELLY CULBERTSON

Acquired for Parkhurst Brothers, Inc., Publishers by:
TED PARKHURST

Editor:
ROGER ARMBRUST

A VISUAL GUIDE
to CLASSICAL ART THEORY
for Drawing and Painting Students

To Lisa

ACKNOWLEDGMENTS

To my parents, whose early encouragement and support inspired a long and rewarding career in art.

To the Cleveland Institute of Art for giving me a thorough classical studio education within their five-year BFA program.

To Ohio University for giving me my first opportunity to teach a class as a graduate assistant within their MFA program. I was hooked from day one.

To Bob McKaskell, friend and colleague, for being the original inspiration behind this book.

To Jef Sturm, friend and colleague, for being a good teacher.

To Gilmour Academy, and specifically to William Fitch, for supporting a previous treatise on classical theory.

To the hundreds of students whose questions over the years inspired many of the ideas presented in this text.

To Win Bruhl, Floyd Martin and Michael Warrick, friends and colleagues at the University of Arkansas at Little Rock, for being patient and supportive of this project.

To Tom Clifton and Carey Roberson, friends and colleagues at UALR whose computer knowledge greatly exceeded mine, for being helpful with this project.

To William Litwa and Scott Strickland, students at UALR whose computer knowledge also greatly exceeded mine, for being helpful with this project.

To Kevin Cates, friend and colleague at UALR, whose computer knowledge, long hours spent and patience was a major help in preparing all pages for publication.

To Ted Parkhurst whose faith in the book, knowledge and patience brought this project to completion.

And to Lisa, wife, colleague, friend and fellow artist who is my inspiration.

PREFACE

The purpose of this book is to explain classical theory in a clear and concise manner to beginning drawing and painting students. As an art student I was frequently frustrated by instructional books that would give lengthy verbal descriptions of visual concepts and then show small and/or unclear diagrams of those concepts. As an art teacher I found that my students gained a clearer understanding of a visual concept when my verbal explanation was combined with a diagram of that concept. Consequently, since the subject of this text pertains to the visual, all theories are presented in a visual manner - a series of diagrams with a minimal amount of copy.

To become a poet or a novelist, one must first understand basic grammar. In essence, this is a book of "art grammar." My teaching philosophy is that all art students should go through two general phases of growth at the university level. The first phase: Gain an understanding of the basic fundamentals of art. This in turn gives a student the necessary tools to begin the second phase of their education: to develop a personal philosophy and to find one's own voice as an artist. This text covers the first phase (the "grammar" phase) of the art student's education in drawing and painting theory. Each page, theory, and diagram represents a different tool for the artist, and with their use comes an infinite number of solutions.

Classical theory began during the early Renaissance as a means of creating representational imagery, and has been refined and clarified over the centuries. Artists from the Post-Impressionist period to the present day continue to use classical theory to create representational, abstract and non-objective imagery that, at times, will intentionally contradict the illusions of traditional volume and depth. A common misunderstanding among art students is that the basic theories of drawing and painting pertain only to representational imagery; but classical theory pertains to non-representational imagery as well. An example: since value changes in a drawing, or color changes in a painting, will create some illusion of depth; it is necessary for the artist working abstractly or non-objectively to understand the theories of atmospheric perspective. The artist can then control the value and color changes for a desired spatial effect, whether it be deep space, shallow space, or no space at all. A second common misunderstanding among art students: The basic theories of drawing and painting pertain only to traditional media. Classical theory pertains to non-traditional media as well. Examples of this include a trompe-l'oeil effect in graffiti art and the illusion of volume and depth created on a computer.

During thirty-four years of teaching foundation courses
in drawing, painting and design on the college level, I was
always searching for the most effective ways to explain basic
concepts to beginning art students. This book is the result of
that teaching experience: a compendium of classical drawing
and painting theory that I use in the classroom for lectures,
demonstrations and discussions. Readers of this text are given
the information to understand the complexities of color theory
and to create the illusion of volume and depth on a two-
dimensional surface. The book is divided into four chapters:
Linear Perspective, Color, Light and Shade, and Atmospheric
Perspective.

CONTENTS

Chapter 1

Linear Perspective

Chapter 2

Color

CONTENTS

CONTENTS

LINEAR PERSPECTIVE

INTRODUCTION

Definition: An object viewed from a distance will appear smaller than when viewed from close range. If you view a circle from head-on, it will appear to be a perfect circle; but if you view that same circle at a forty-five degree angle, it will appear to be an oval. In essence, linear perspective is a means to create the illusions of depth and the angle of viewing on a two-dimensional surface. Use of linear perspective allows the artist to inform the viewer where an object is located in space and from what angle an object is viewed. Artists began to understand the concept of linear perspective in the early 1300s, and by the mid-1400s artists were using linear perspective to create effective and complex illusions.

Combining Technical and Visual Approaches: Good linear perspective combines technical knowledge as well as visual observation skills. Students who use only technical knowledge with no visual observation skills will find their drawn images to be somewhat distorted. Conversely, students who use only visual observation skills with no technical knowledge will also find their drawn images to be distorted, but in a different and equally ineffective way. The ability to simultaneously use both technical knowledge and visual observation skills will come over time.

THE PREMISE OF LINEAR PERSPECTIVE

Illusion of Depth

Objects appear to change in size and/or shape when viewed at different locations in space. An object will appear to change in size based on its horizontal distance (nearer or farther) from the viewer; an object will appear to change in size and shape based on its vertical distance (up or down) from the viewer, and an object will appear to change in shape based on the viewing angle. Due to the illusion of linear perspective, a large object can be transformed into a smaller object; a square into a trapezoid or even a straight line; a circle into an oval or a straight line, and parallel lines can converge.

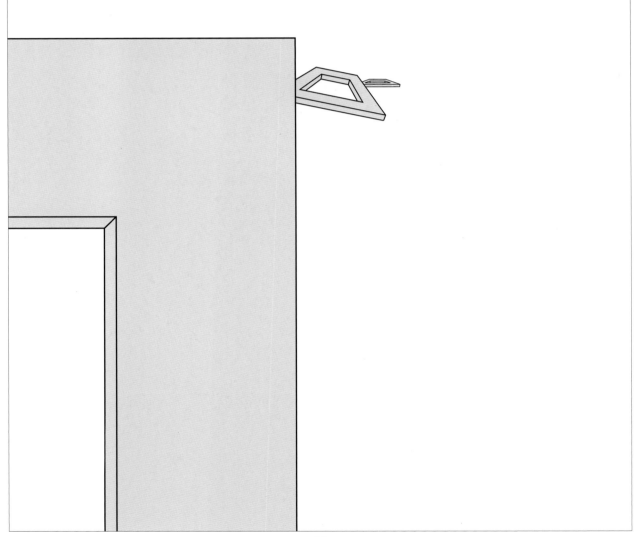

THREE-POINT PERSPECTIVE

Introduction

Vanishing Point (VP): A point in space where parallel lines appear to converge.

All lines or edges that are parallel in nature will appear to converge at the same vanishing point.

The edges of the gray cube are drawn in isometric perspective (parallel to each other), and therefore will not converge. The edges of the white cube are drawn with the illusion of three-point perspective, and thereby converge at their three respective vanishing points.

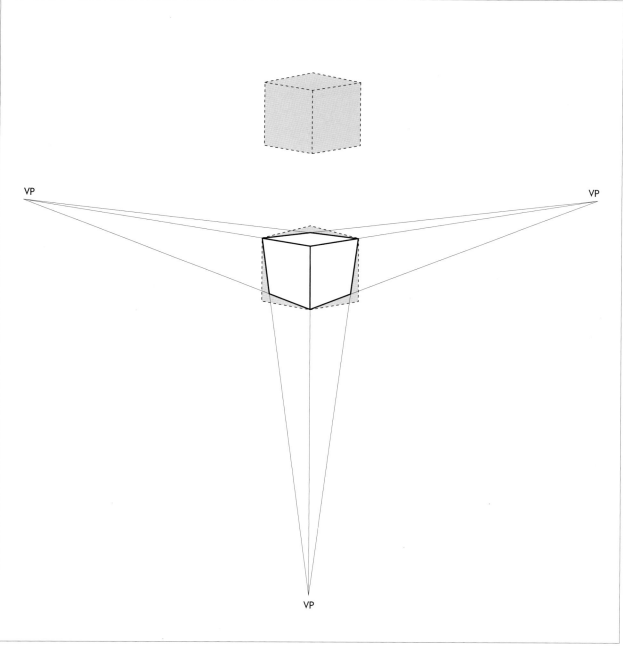

Parallel Objects

When cubes are parallel to each other, their edges will appear to converge at the same three vanishing points. The dotted line above the objects represents the horizontal plane of vision (the viewer's eye level), which will be explained further on page 32.

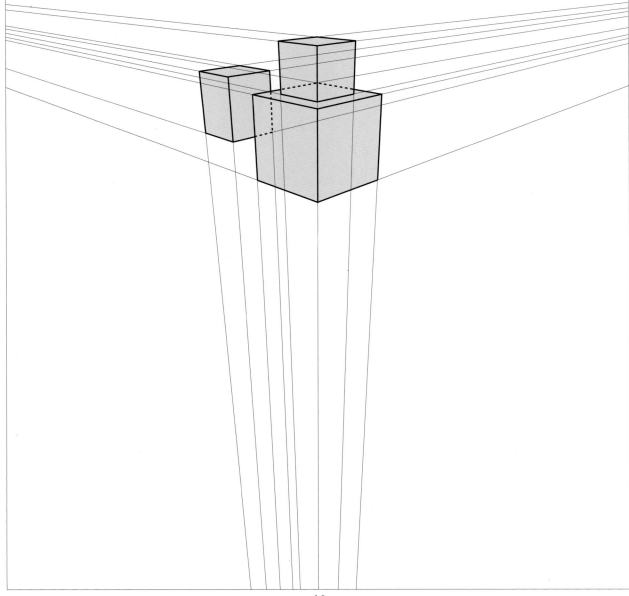

HORIZONTAL PLANE OF VISION

Rotated Objects

A cube that is rotated horizontally (one that stays on the same table surface but is turned at an angle) will keep its same lower vanishing point, but will create two new upper vanishing points. The two new vanishing points will remain on the horizontal plane of vision.

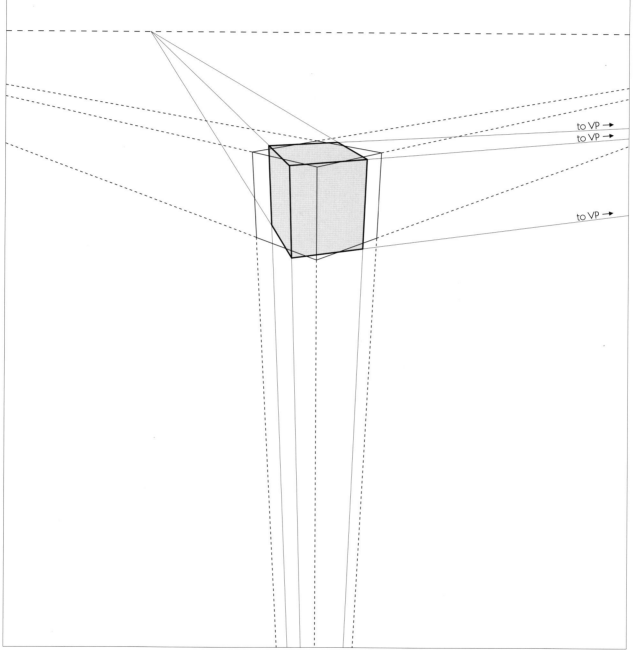

Nonparallel Objects

Lines or edges not parallel in nature will appear to converge at different vanishing points.

The white and gray cubes have no common parallel edges, therefore each object has its own set of three vanishing points.

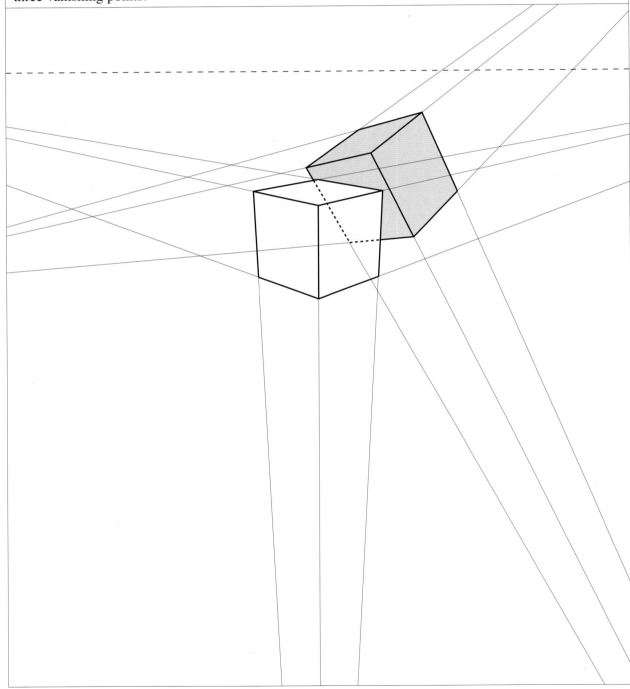

Objects Above Eye Level

Objects above the viewer's eye level will have the third vanishing point placed above, rather than below, the objects. In essence, this is the same diagram from page 16 turned upside-down.

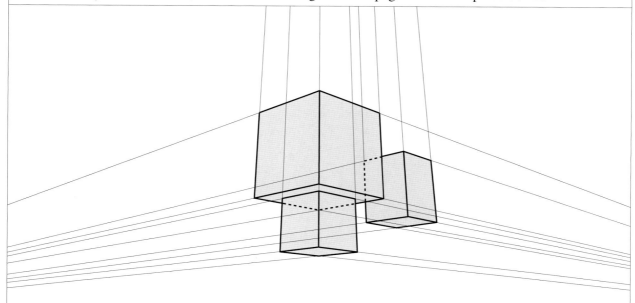

HORIZONTAL PLANE OF VISION

Location of Vanishing Points

All vanishing points are equidistant from the viewer in space, but in most cases they are beyond our scope of vision. Beginning art students frequently either understate or overstate vanishing point locations in their drawings. A relatively small window exists in which vanishing points are used effectively. Diagram A shows an understated approach, with no vanishing points and all lines parallel. Diagram B shows an overstated approach: The vanishing points are too close to the object. Diagram C shows an effective approach: The vanishing points are a distance from the object, and therefore the object's edges angle in slightly.

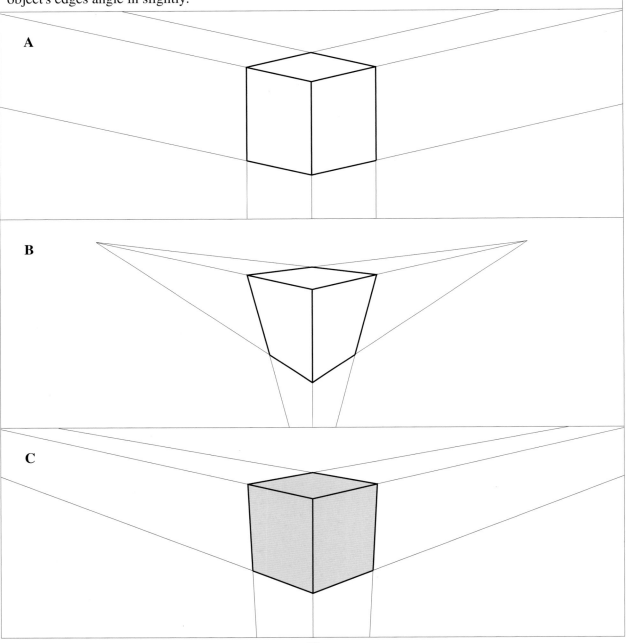

TWO-POINT PERSPECTIVE

Introduction

In two-point perspective, an object's vertical edges are drawn as true vertical (parallel) lines and will not converge at a vanishing point.

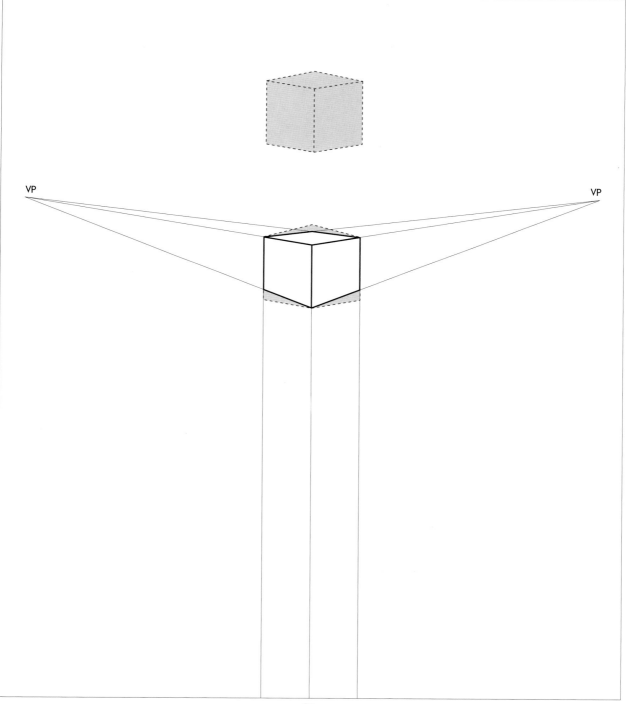

Comparison with Three-Point Perspective

While two-point perspective is technically not as accurate as three-point perspective due to the missing vanishing point, two-point perspective will often cause less distortion of objects. Two-point perspective is frequently recommended for drawing smaller objects such as those in a still life, as well as smaller architectural objects such as houses and small buildings. In three-point perspective, objects or parts of objects that are farther from an image's vertical center can tend to lean right or left.

Two-Point Perspective

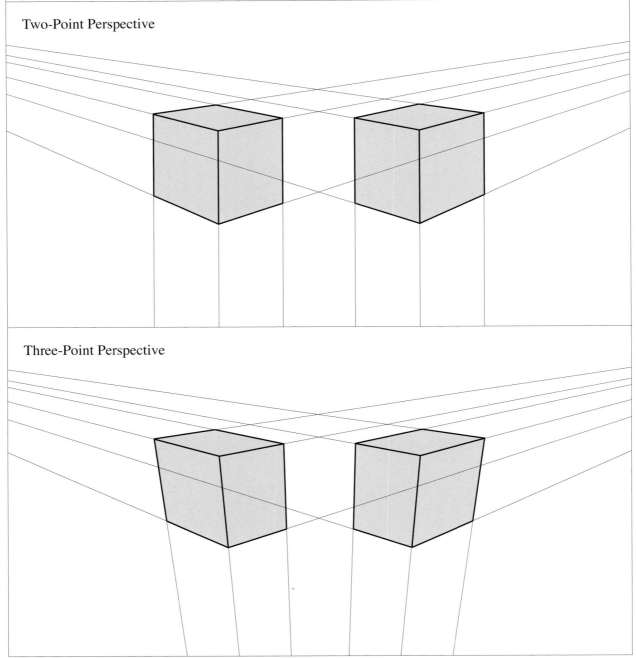

Three-Point Perspective

CIRCLES

Construction within a Square

A circle can be constructed within a square drawn in perspective.

The upper series of diagrams (1-4) illustrate the step sequence to construct a freehand circle within a square: Draw a square (diagram 1), draw diagonal lines from corner to corner (diagram 2), through the intersection of the diagonals, draw lines that parallel the square's sides (diagram 3), draw a circle so it coincides where the previous lines bisect the sides of the square (diagram 4). The lower series of diagrams (1a-4a) illustrate the same sequence, but with a square drawn in perspective. In step 3a, be sure that the lines (which were parallel to the sides of the square in diagram 3) now go to the appropriate vanishing points.

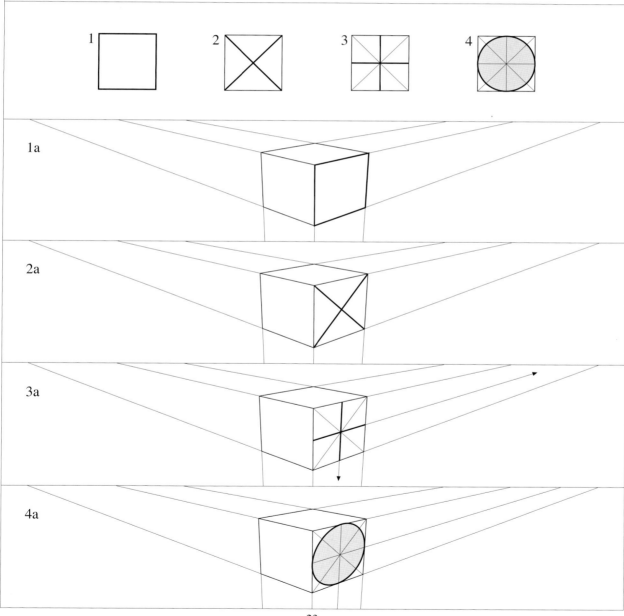

Continued

The previous steps can be applied to all planes of a cube.

MAJOR AXIS OF A CIRCLE
Coinciding with the Major Axis of a Square

Major axis: The longest possible measurement within a symmetrical, geometric shape.

The major axis of a circle will coincide with the major axis of the square that it is constructed within.

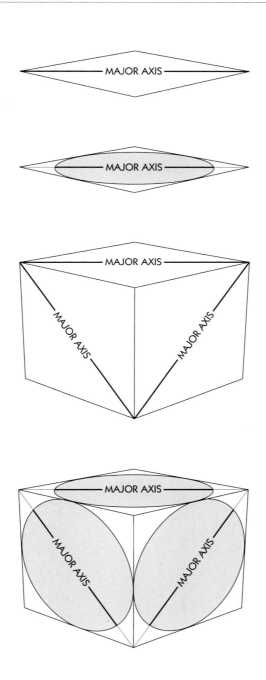

Angle Variations

The major axes of circles will vary in angle depending on the major axes of the squares they are constructed within.

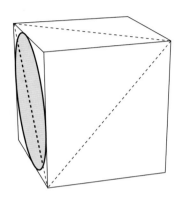

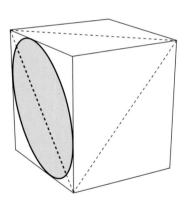

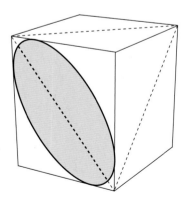

CYLINDERS

Construction within a Cube

A cylinder can be constructed within a cube drawn in perspective.

The bottom plane of a cube is drawn by extending lines from corner A to the right vanishing point and from corner B to the left vanishing point. Circles are constructed within both the top and bottom planes of the cube by using the same steps on pages 23 and 24.

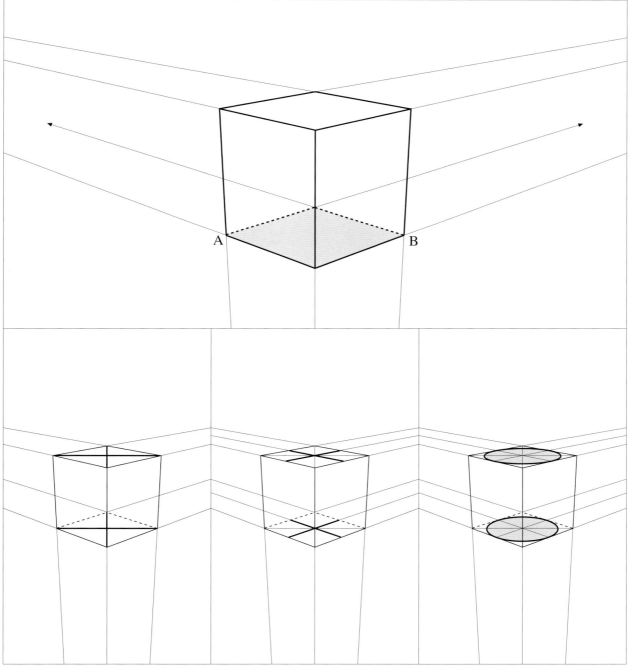

Continued

The final step is to extend the sides of the cylinder (A and B) to the lower vanishing point.

A

B

MAJOR AXES OF CIRCLES IN A CYLINDER

Parallel Lines

The major axes of circles in a cylinder will be parallel to each other.

MAJOR AXES OF CIRCLES IN A CYLINDER

Horizontal Lines

When cylinders are sitting on a horizontal surface (floor, table, etc.), the major axes of all the circles will be horizontal lines.

FORESHORTENING

Definition

Foreshortening: A foreshortened plane or object is one that recedes in space; i.e., part of the plane or object is closer to the viewer than other parts.

The two examples on the right show side views of the observer (arrow) and the object.

FRONTAL
(Not Foreshortened)

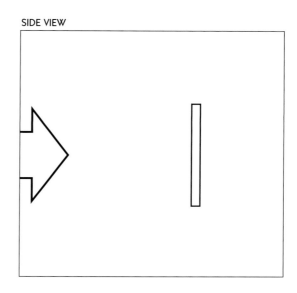

SIDE VIEW

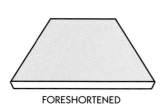

FORESHORTENED

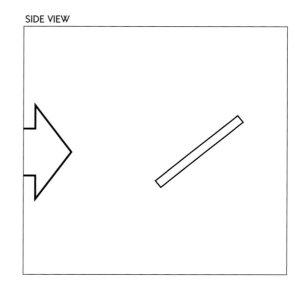

SIDE VIEW

Planes of Vision

Planes of Vision: Two imaginary planes, horizontal (diagram A) and vertical (diagram B) that extend infinitely from the viewer's eye level.

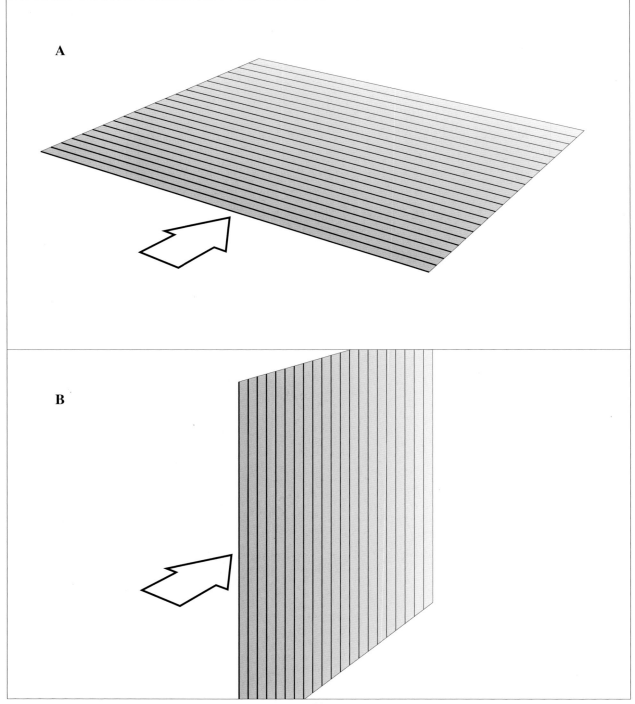

A

B

FORESHORTENING

Horizontal Plane of Vision

The closer an object is to the horizontal plane of vision, the more foreshortened it will appear.

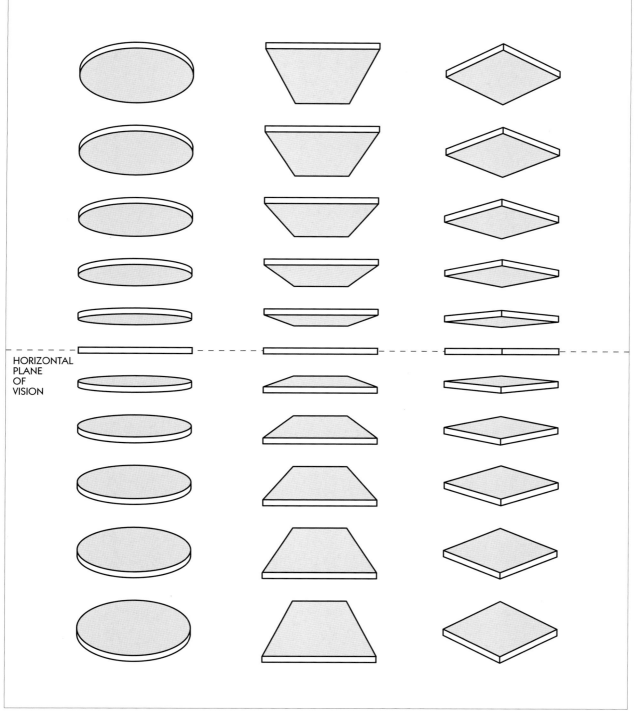

HORIZONTAL
PLANE
OF
VISION

Continued

Individual planes within an object are different distances from the horizontal plane of vision, and therefore are foreshortened to different degrees.

Vertical Plane of Vision

The closer an object is to the vertical plane of vision, the more foreshortened it will appear.

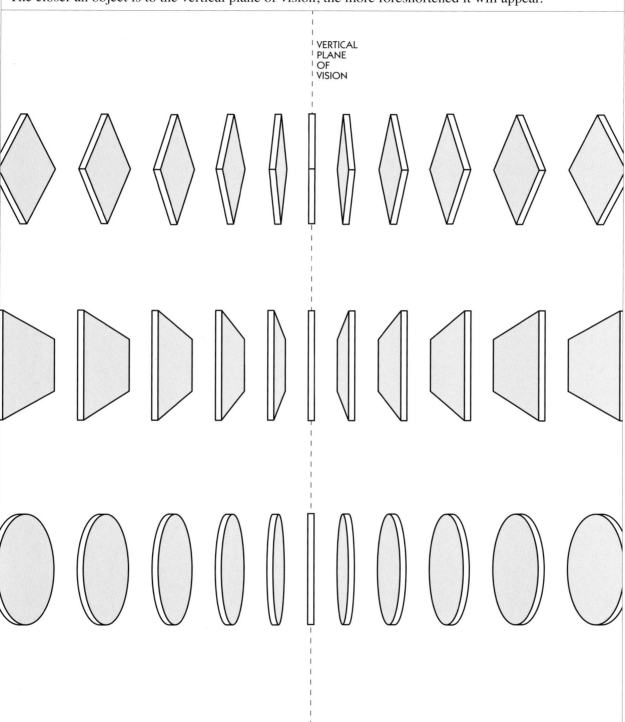

VERTICAL
PLANE
OF
VISION

Continued

Individual planes within an object are different distances from the vertical plane of vision and therefore are foreshortened to different degrees.

COMBINED PLANES OF VISION

Introduction

Horizontal and vertical planes of vision viewed simultaneously.

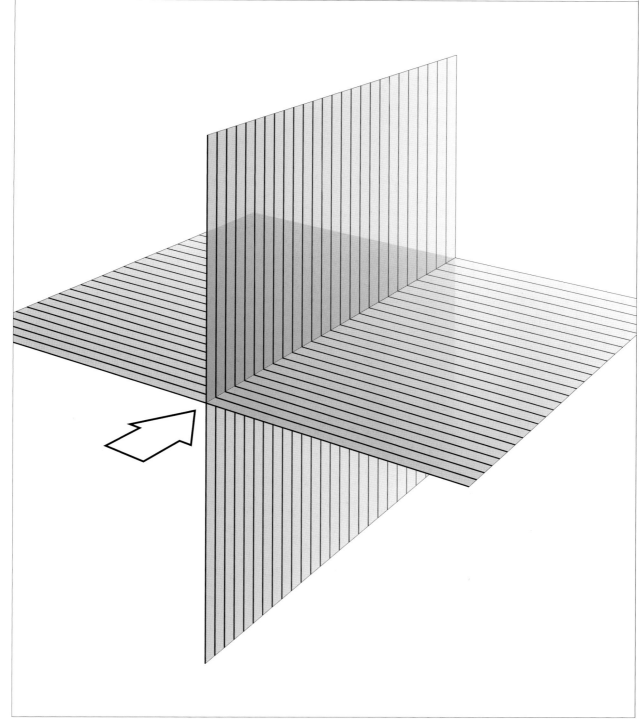

Frontal Cubes

Frontal cubes as seen in relation to the combined planes of vision.

Angled Cubes

Angled cubes as seen in relation to the combined planes of vision.

VERTICAL ROTATION

Cylinders

As objects rotate in space or are viewed from different angles, the degree of foreshortening changes with each plane. The objects on the following three pages are rotating vertically 180 degrees directly in front of the viewer. The diagrams on the right show side views of the observer (arrow) and the rotating object.

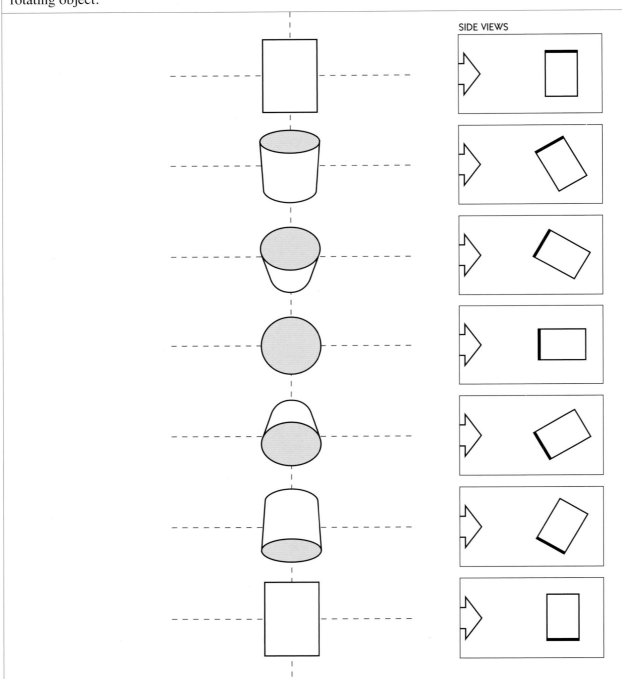

SIDE VIEWS

Frontal Cubes

SIDE VIEWS

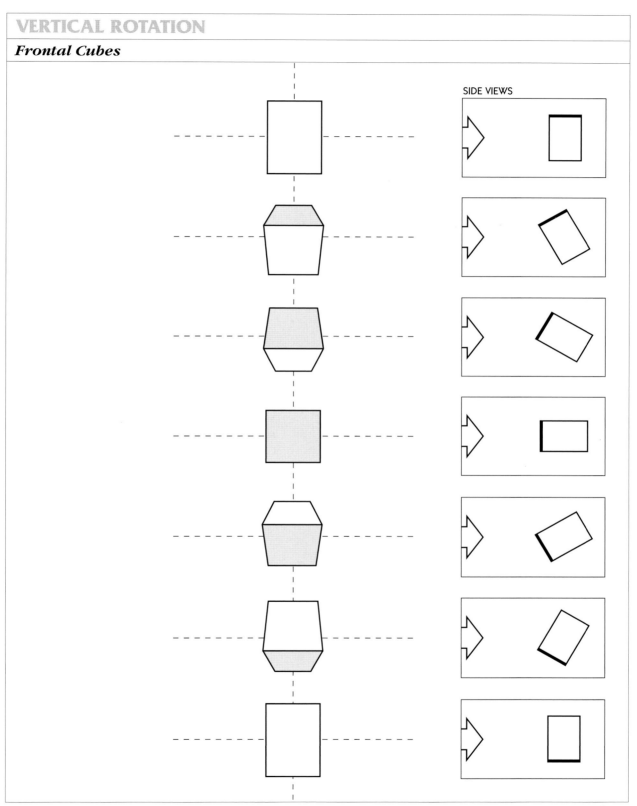

41

Angled Cubes

SIDE VIEWS

HORIZONTAL ROTATION

Cylinders

The objects on the following three pages are rotating horizontally 180 degrees directly in front of the viewer. The diagrams on the right show top views of the observer (arrow) and the rotating object.

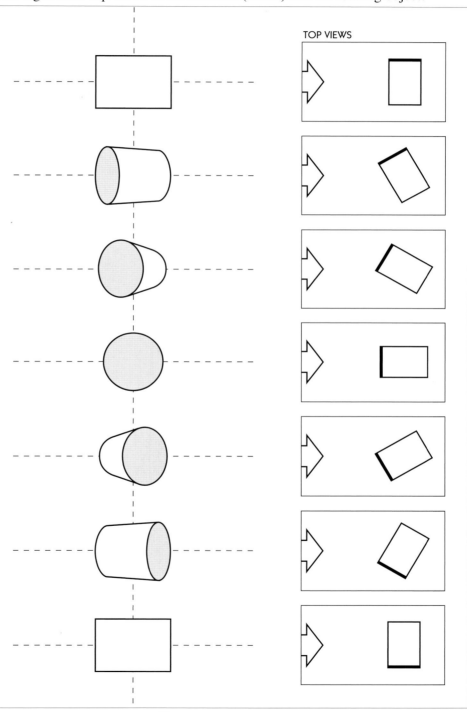

TOP VIEWS

Frontal Cubes

TOP VIEWS

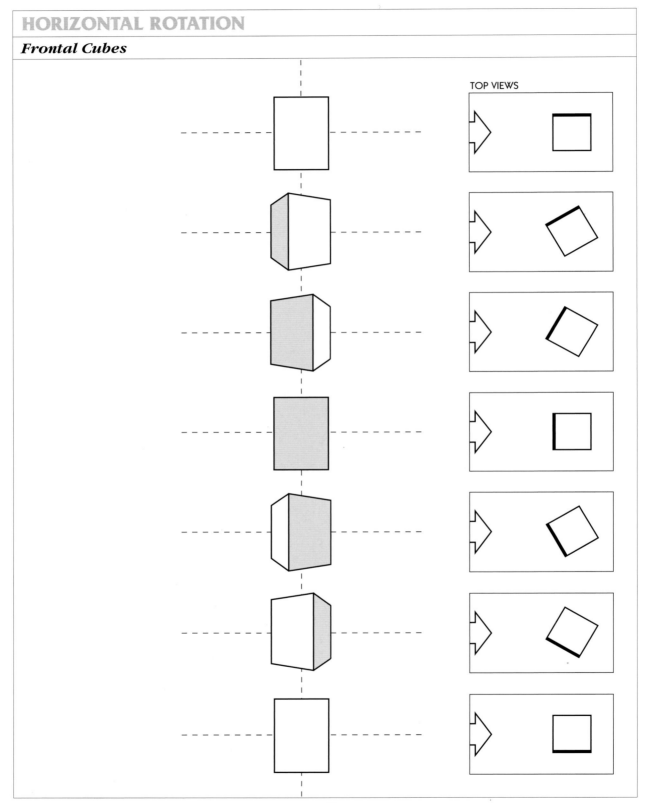

Angled Cubes

TOP VIEWS

RELATIVE FORESHORTENING

Ground Plane

Ground Plane: Horizontal plane on which objects are located - floor, table, etc.

Objects on the same ground plane should be foreshortened in relation to each other.

The two objects in diagram A are foreshortened to the same degree as each other, and therefore appear to be on the same ground plane. The two objects in diagram B are foreshortened to the same degree as each other, and also appear to be on the same ground plane. Objects that are not foreshortened in relation to each other will appear as though on different ground planes (diagrams C and D). The cylinder in diagram C is more foreshortened than the cube, and the cube in diagram D is more foreshortened than the cylinder.

Objects on the same ground plane.

A

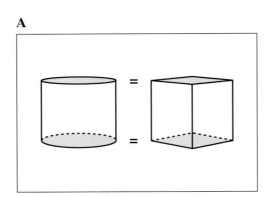

B

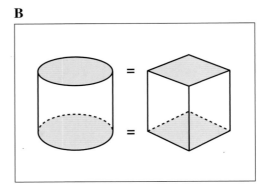

Objects not on the same ground plane.

C

D

DETAIL

Foreshortened Planes

Detail can be constructed on a foreshortened plane.

The upper series of diagrams illustrate the step sequence to construct detail within a square: Draw a square (diagram 1); draw diagonal lines from corner to corner to establish the center point of the square (diagram 2); through the intersection of the diagonals, draw lines that parallel the sides of the square (diagram 3); repeat the previous step four more times within each quadrant of the square (diagram 4). The lower series of diagrams illustrate the same sequence of steps within a foreshortened square. In the third and fourth steps, be sure that the horizontal lines (which were parallel to the sides of the squares in the previous series) now go to the appropriate vanishing points.

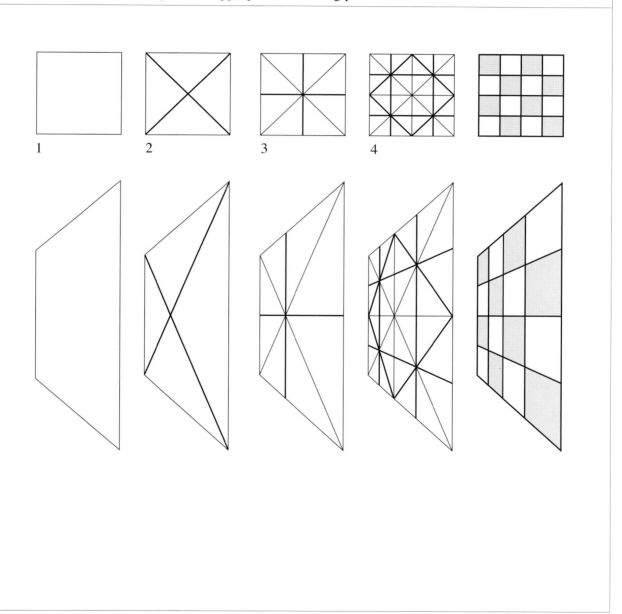

Foreshortened Curved Surfaces

Detail can be constructed on a foreshortened curved surface.

Establish the major axis on the top of a cylinder and draw two vertical lines extending from the major axis (diagram 1); draw a circle within the two vertical lines (diagram 2); divide the circle into any number of equal segments (diagram 3); project vertical lines from the segments to the top of the cylinder (diagram 4), and extend the lines from the top of the cylinder to the lower vanishing point (diagram 5).

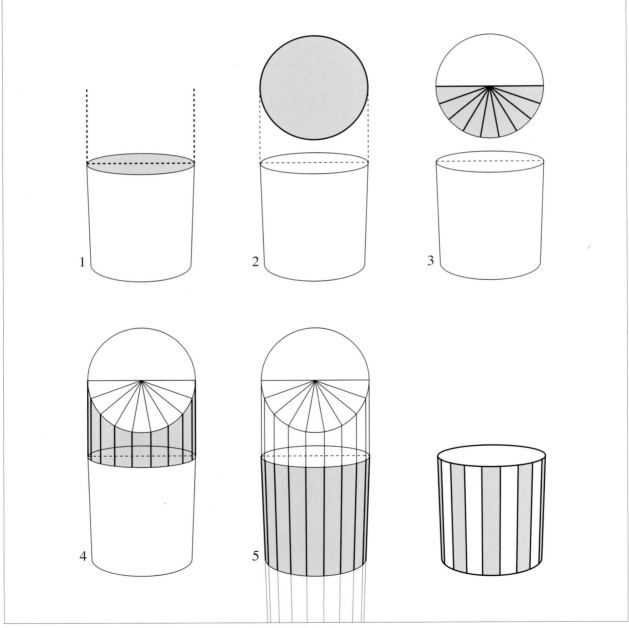

SHADOWS

Cube

The shape of a shadow cast by a cube is determined by the intersections of lines projected from the light source (A) through points on the object's top plane (1a, 2a, 3a), and from lines projected from a point on the ground plane directly below the light source (B) through corresponding points on the object's bottom plane (1b, 2b, 3b).

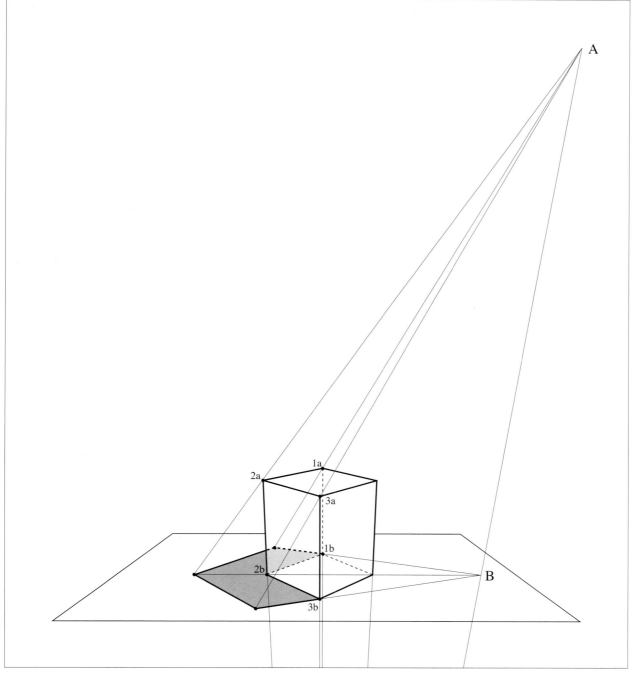

Cylinder

The shape of a shadow cast by a cylinder is also determined by the intersections of lines projected from the light source (A) through points on the object's top plane (1a, 2a, 3a, 4a, 5a), and from lines projected from a point on the ground plane directly below the light source (B) through corresponding points on the object's bottom plane (1b, 2b, 3b, 4b, 5b).

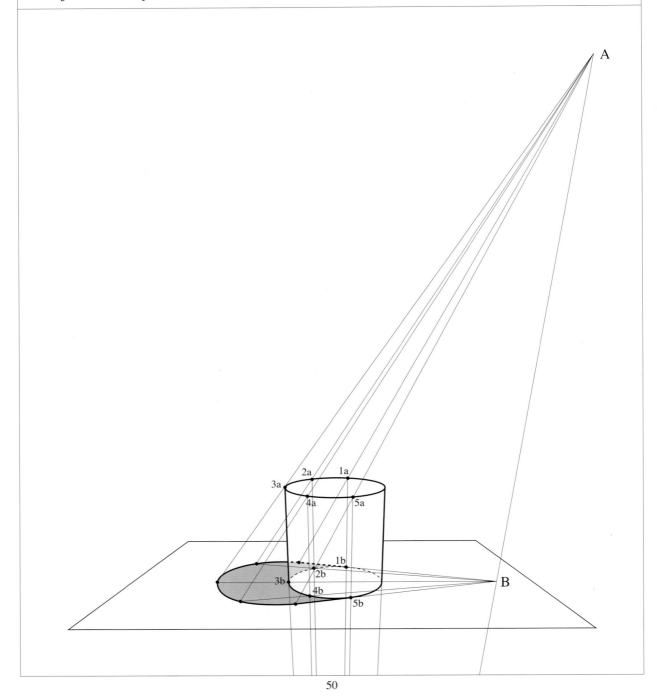

Sphere

The shape of a shadow cast by a sphere is determined by the intersection of lines projected from the light source (A) through points on the sphere's surface in the form of a circle. The circle should be perpendicular to a center line projected from the light source (B).

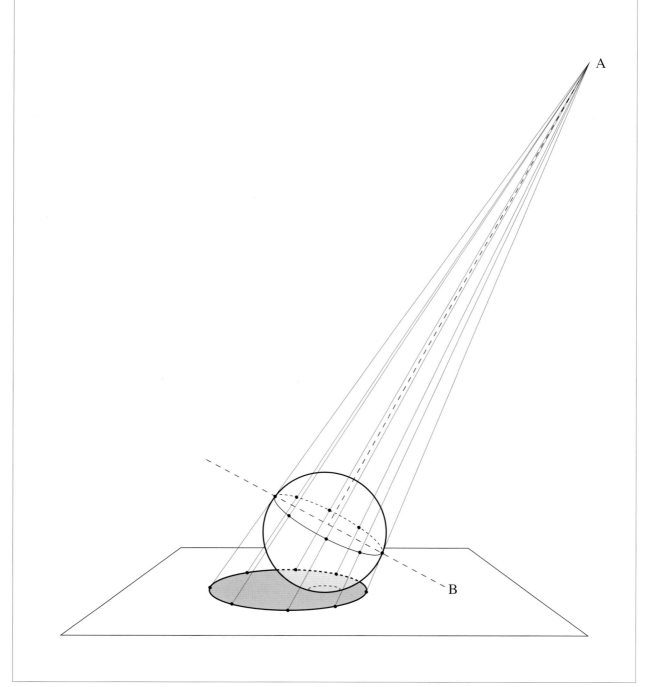

General Shape

With the light source to one side of an object, the shadow begins by repeating the shape of the object's side (Diagram A), and ends by repeating the shape of part of the object's top plane (Diagram B).

A

 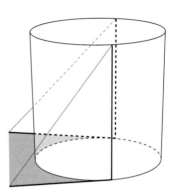

B

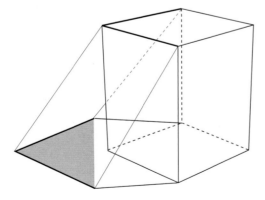 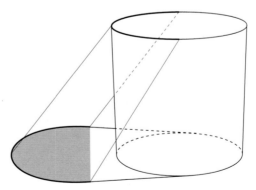

Width

Shadow width is determined by the light source's location. A shadow will be wider if the light source is placed closer to the object, and narrower if the light source is placed farther from the object.

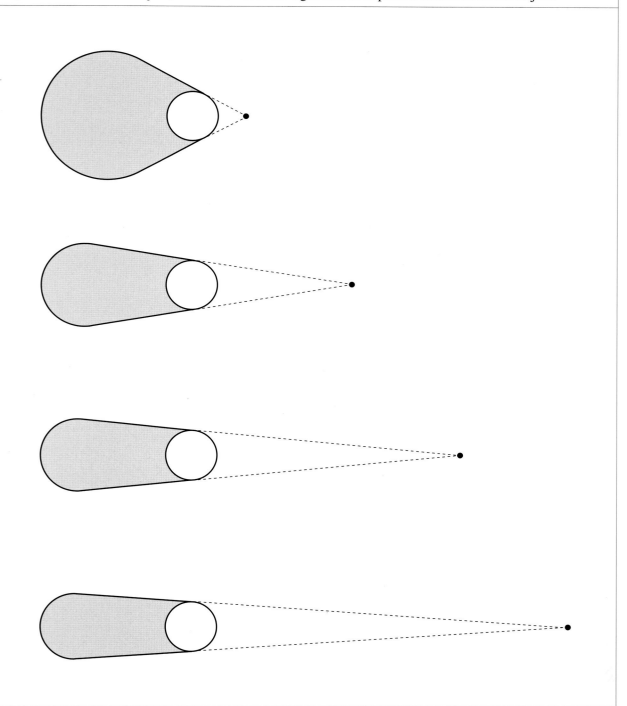

Length

Shadow length is also determined by the light source's location. A shadow will be shorter if the light source is placed high above the ground plane, and longer if the light source is placed closer to the ground plane.

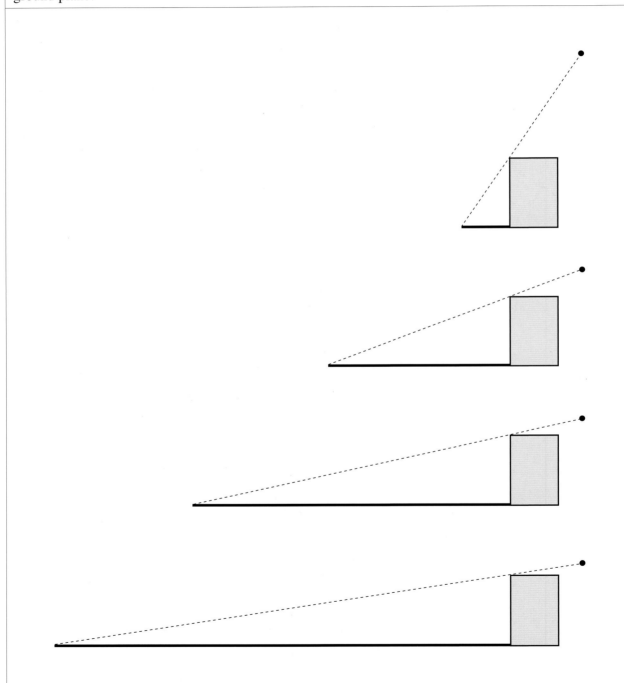

FOUR-POINT PERSPECTIVE (CURVILINEAR PERSPECTIVE)

Horizontal Plane of Vision

The following three pages illustrate only the basic premise as an introduction to the concept of four-point perspective. A thorough explanation of curvilinear perspective is worthy of an entire text.

Frequently, an object we view in everyday life will simultaneously extend above and below our horizontal plane of vision. That same object can also simultaneously extend to the left and to the right of our vertical plane of vision. (An example: A viewer stands in the center of a room facing one of the walls. The wall extends above and below, as well as to the left and right of, the viewer's planes of vision.) Consequently, to draw such an object in perspective, we need a fourth vanishing point. To take the concept one step farther, the lines between the vanishing points will curve, and therefore the object's edges will appear to curve.

Diagram A shows an object viewed above the horizontal plane of vision; diagram B shows an object viewed below the horizontal plane of vision, and diagram C shows an object in four-point perspective that extends above and below the horizontal plane of vision.

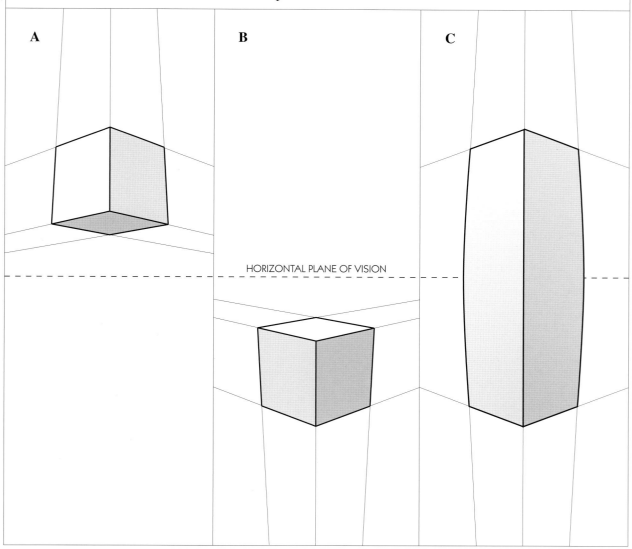

A

B

C

HORIZONTAL PLANE OF VISION

FOUR-POINT PERSPECTIVE (CURVILINEAR PERSPECTIVE)

Vertical Plane of Vision

Diagram A shows an object viewed to the left of the vertical plane of vision; diagram B shows an object viewed to the right of the vertical plane of vision, and diagram C shows an object in four-point perspective that extends to the left and to the right of the vertical plane of vision.

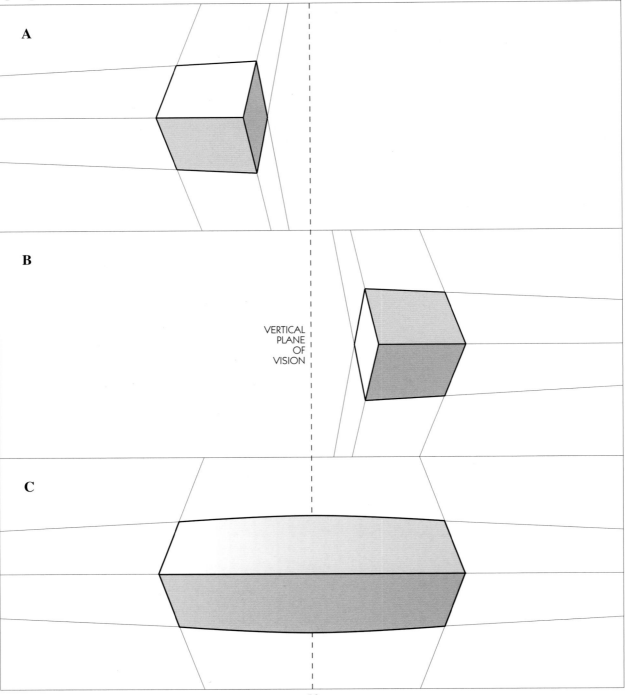

VERTICAL
PLANE
OF
VISION

Combined Planes of Vision

Diagram A shows an object that extends above and below the horizontal plane of vision; and that also extends to the left and to the right of the vertical plane of vision. Diagram B shows the object in four-point perspective.

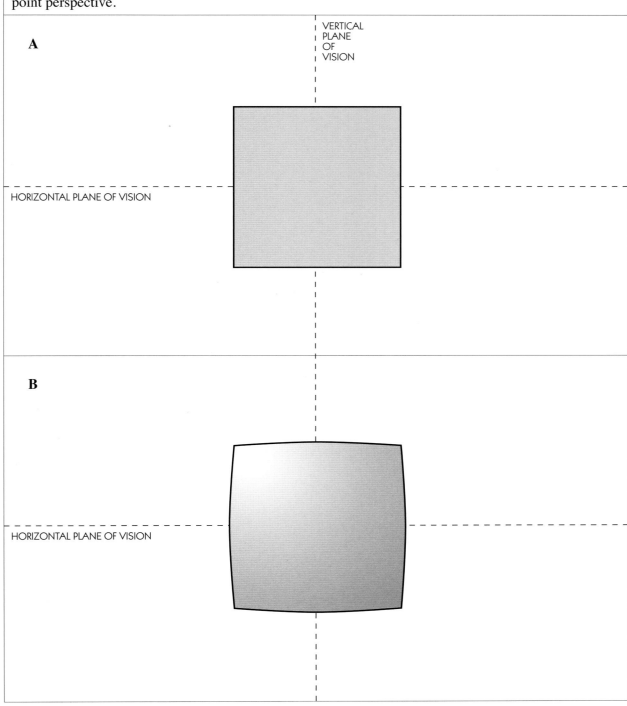

A

VERTICAL
PLANE
OF
VISION

HORIZONTAL PLANE OF VISION

B

HORIZONTAL PLANE OF VISION

COLOR

INTRODUCTION

Light and Pigment: The human eye sees color in two ways: through light (additive color) in which light itself is used to create color, and is utilized primarily by video artists, set designers, etc.; and through pigment (subtractive color) in which light is reflected off a surface to create color, and is used primarily by painters, printmakers, etc. The color theories in this book pertain to pigment.

The Color Wheel: The theory of the twelve-step color wheel with three primary colors, which will be used in this book, was developed in the early 1700s, and has been a standard ever since. Two theories developed during the early 1900s: the Ostwald system with four primary colors and a twenty-four step color wheel, and the Munsell system with five primary colors and a ten-step color wheel. Both are worth being aware of.

The Properties of Color: Color theory is a three-dimensional concept in which colors can be identified and changed in three different ways. All colors have three distinct parts which can be thought of as the dimensions, variables, characteristics, elements, or the properties of color. The three properties of color are named **hue**, **chroma**, and **value** and are defined on pages 60, 61 and 62 respectively.

The Color Solid: The theory of a three-dimensional representation of color was also developed in the 1700s following the color wheel's creation. The three-dimensional concept of color is best understood by learning to visualize a three-dimensional image called a color solid, which incorporates the interrelation of all three properties of color. For an art student to be able to manipulate color for a desired effect, it is necessary to understand how hue, chroma and value interrelate, i.e., how each property is affected by the other two, and how each property is affected when one color is added to another. The premise of the color solid is explained on page 63, the concept behind the color solid's construction is explained on pages 64 through 67, and different views of the color solid are shown on pages 68 through 75.

THE PROPERTIES OF COLOR

Hue

Properties of Color: The three parts of color: hue, value and chroma. The three ways to identify or change a color.

Hue: The quality of a color (the redness, the blueness, etc.) that designates its name as well as its position on the color wheel.

Color Wheel: A representation of variations in hue at full intensity.

Primary Colors: Red, yellow, and blue. All colors on the color wheel can be made by mixing different ratios of the three primary colors.

Secondary Colors: Green, purple, and orange. Secondary colors can be made by mixing equal parts of two primary colors. Yellow + blue = green, blue + red = purple, red + yellow = orange.

Tertiary Colors (Intermediate Colors): Red-orange, yellow-orange, yellow-green, blue-green, blue-purple, and red-purple. Tertiary colors can be made by mixing equal parts of a primary color and an adjacent secondary color. Red + orange = red-orange, etc.

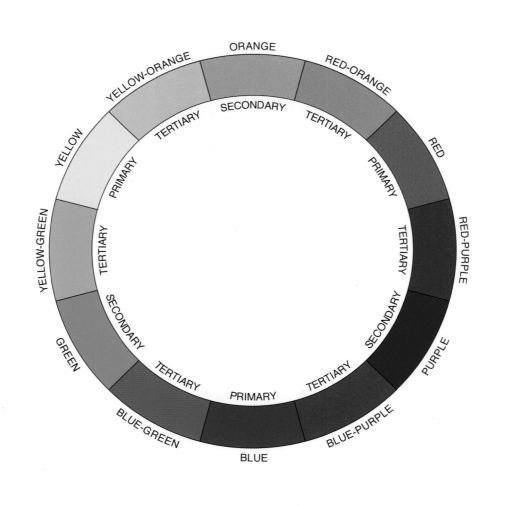

THE PROPERTIES OF COLOR

Chroma (Intensity, Saturation)

Chroma: The brightness or dullness of a color.

In the circular diagram below, the colors farthest from the center are the brightest. As the colors approach the center of the circle, they become increasingly dull.

Chroma Scale: A gradation of two complementary hues from bright to dull to bright, with colors of full intensity at both ends of the scale and a neutral in the middle.

Full Intensity: A color is at full intensity if it is as bright as possible. The colors on the perimeter of the circular diagram are at full intensity.

Neutral (Gray): A color that has no intensity. It can be made by mixing equal parts of two complementary colors, or by mixing black and white. The color in the center of the circular diagram is a neutral.

Middle Chroma: A color halfway between full intensity and neutral on the chroma scale.

Complementary Colors: Any two diametrically opposite colors on the color wheel. Red is the complement of green, yellow is the complement of purple, etc.

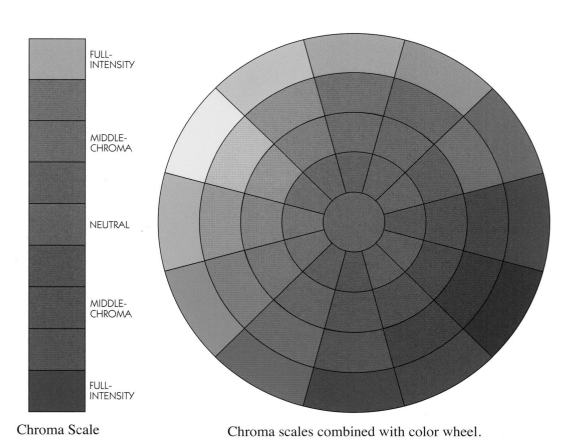

Chroma Scale

Chroma scales combined with color wheel.

Value

Value: The lightness or darkness of a color.

Value Scale: A gradation of grays (neutrals) from light to dark, with white at one end of the scale and black at the other end.

Middle Value: The color halfway between black and white on the value scale.

Tint: A color made lighter in value by adding white.

Shade: A color made darker in value by adding black.

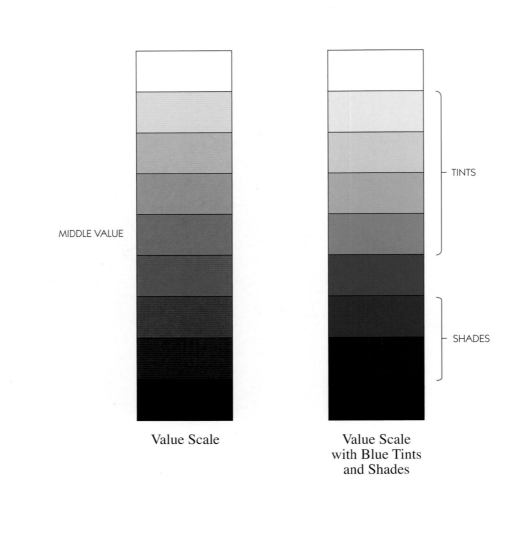

Value Scale

Value Scale
with Blue Tints
and Shades

THE PREMISE OF THE COLOR SOLID

The Relative Values of Hues

The colors on the color wheel can obviously be seen in terms of hue (red, blue, etc.), but they can also be seen in terms of value (lighter or darker). For example, the yellow on the color wheel is very light in value, and therefore is placed high on the value scale. Yellow-orange and yellow-green are slightly darker in value than the yellow, and therefore are placed one step down on the value scale, and so on. Purple on the color wheel is very dark in value, and therefore is placed near the bottom of the value scale.

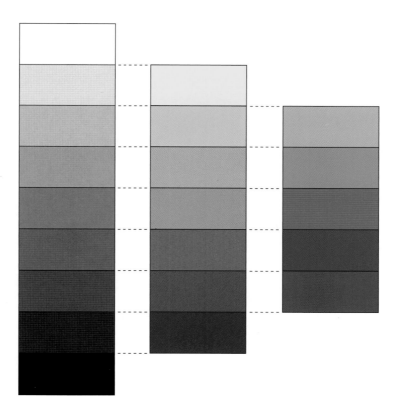

CONSTRUCTION OF THE COLOR SOLID

Step 1

The color solid can be constructed by taking the color wheel from page 60 and the value scale from page 62 (left diagram), creating them as three-dimensional images (center diagram), placing the value scale through the center of the color wheel (right diagram)...

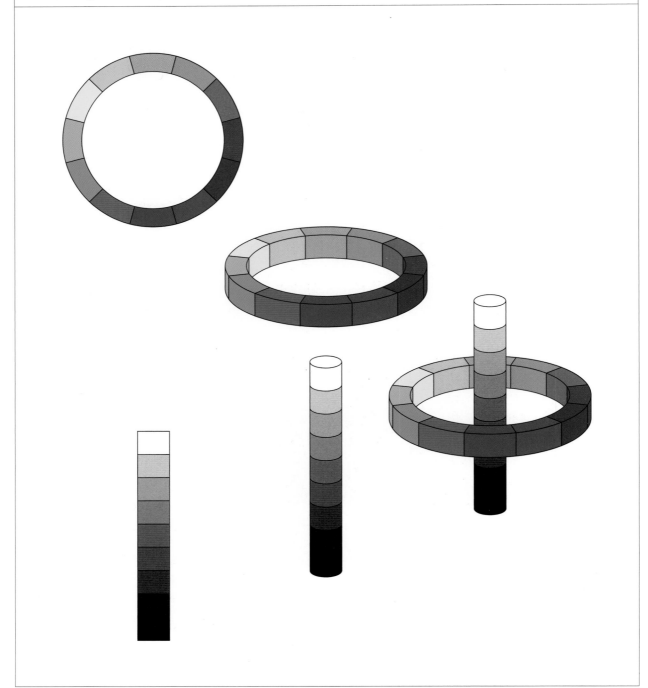

Step 2

...vertically adjusting the colors of the color wheel...

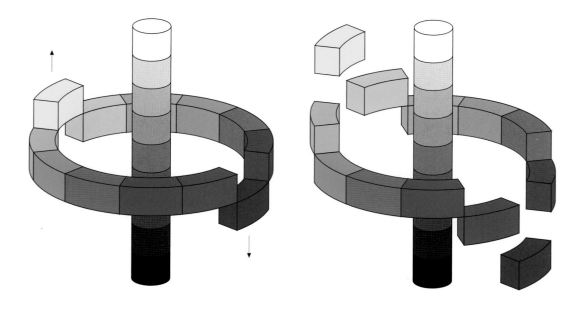

Continued

...so they are placed on the same horizontal level as their corresponding values (see page 63)...

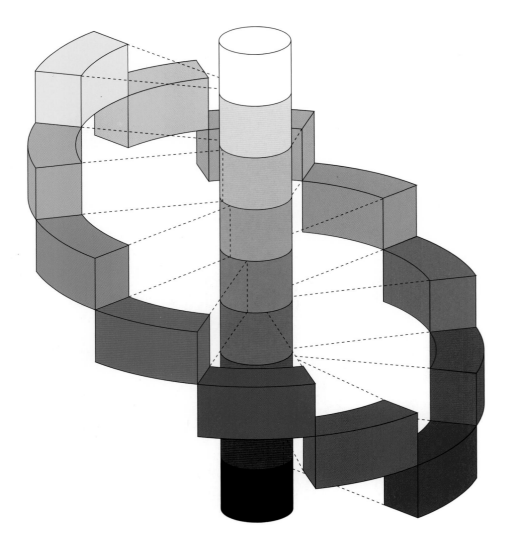

Step 3

...and then including all other changes in value and chroma...

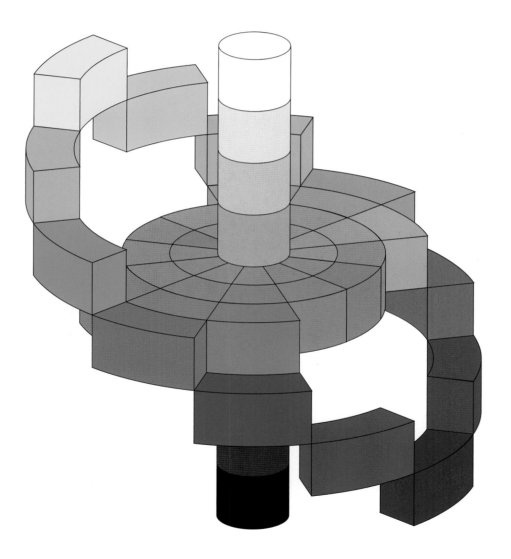

THE COLOR SOLID

View 1

...to create the color solid.

Color Solid: A three-dimensional representation of variations in hue, value and chroma.

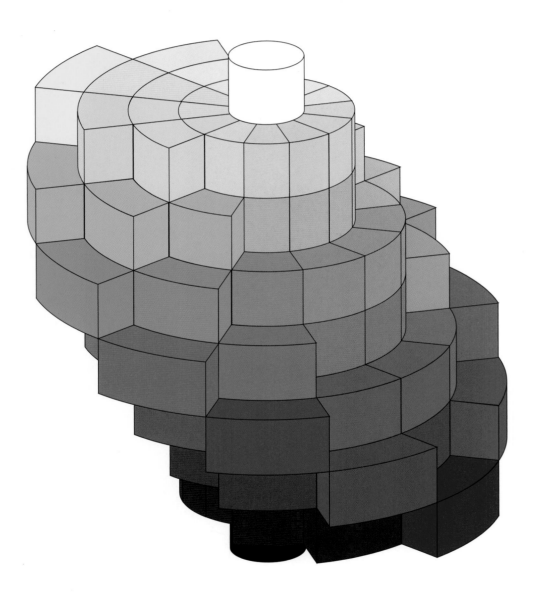

180° View

The color solid as seen from the opposite side.

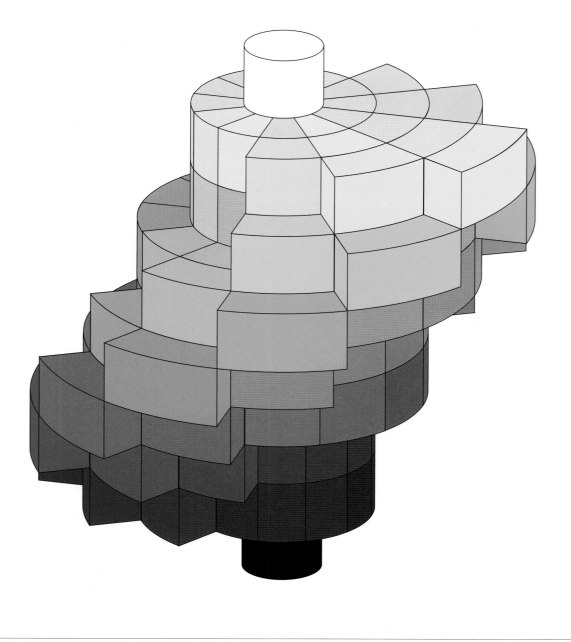

180° Exploded View

THE COLOR SOLID

Changes in the Properties of Color

Hue: Changes in hue (changes from red, to red-orange, to orange, etc.) occur in a circular direction around the color solid.

Value: Changes in value (from light to dark, or from dark to light) occur vertically within the color solid, with lighter colors toward the top of the color solid, and darker colors toward the bottom.

Chroma: Changes in chroma (from bright to dull, or from dull to bright) occur horizontally within the color solid, with brighter colors toward the outside of the color solid, and duller colors toward the inside.

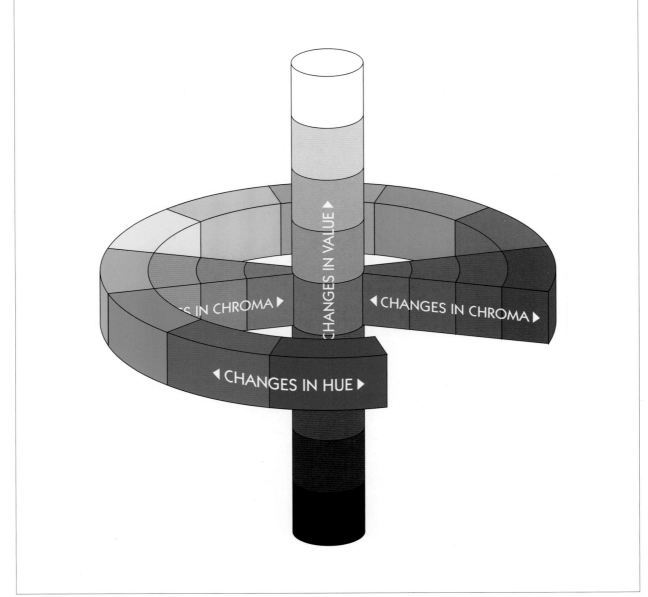

Changes in Hue

All colors in each individual wedge are the same hue, with changes in hue occurring in a circular direction around the color solid.

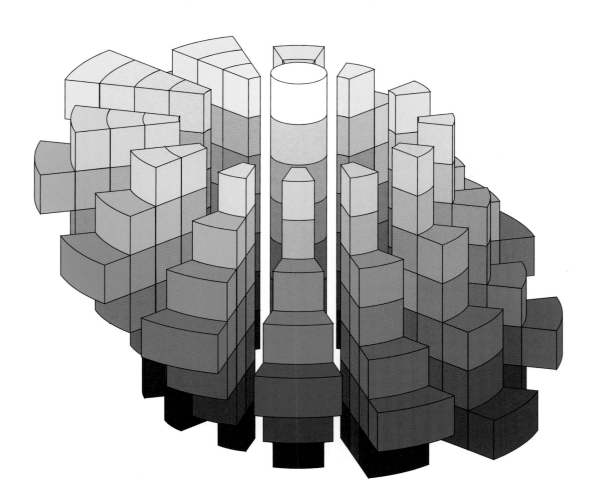

Changes in Value

All colors in each horizontal plane are the same value, with lighter colors toward the top of the color solid and darker colors toward the bottom.

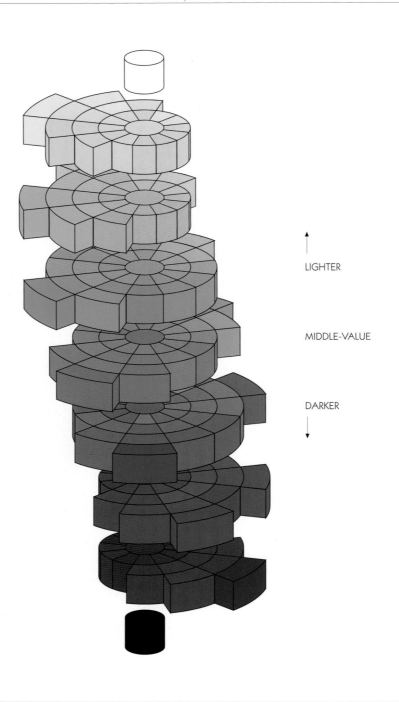

LIGHTER

MIDDLE-VALUE

DARKER

Changes in Chroma

All colors in each individual layer are the same chroma, with brighter colors toward the outside of the color solid and duller colors toward the inside.

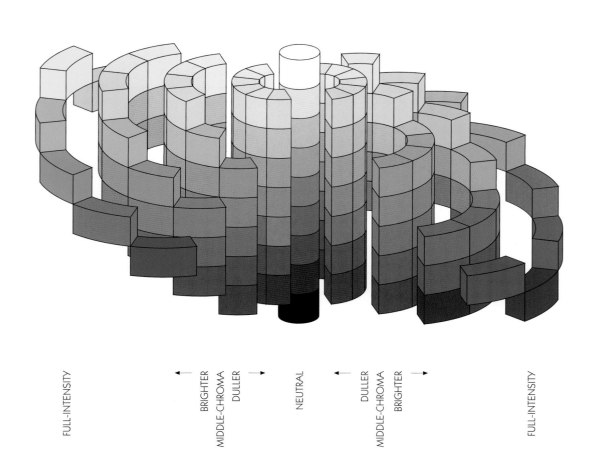

FULL-INTENSITY

← BRIGHTER MIDDLE-CHROMA DULLER →

NEUTRAL

← DULLER MIDDLE-CHROMA BRIGHTER →

FULL-INTENSITY

VERTICAL CROSS SECTIONS OF THE COLOR SOLID

Changes in Hue, Value and Chroma

Vertical cross sections of the color solid show color variations for each hue in relation to value and chroma.

Hue: Colors on one side of the value scale in each cross section are all the same hue, with changes in hue occurring on opposite sides of the value scale (diagram A).

Value: Colors in each horizontal row are all the same value. Colors become progressively lighter toward the top of each cross section, and progressively darker toward the bottom of each cross section, (diagram B).

Chroma: Colors in each vertical row are all the same chroma. Colors become progressively brighter toward the outside of each cross section, and progressively duller toward the center of each cross section, (diagram C).

The vertical cross sections are illustrated on the following three pages.

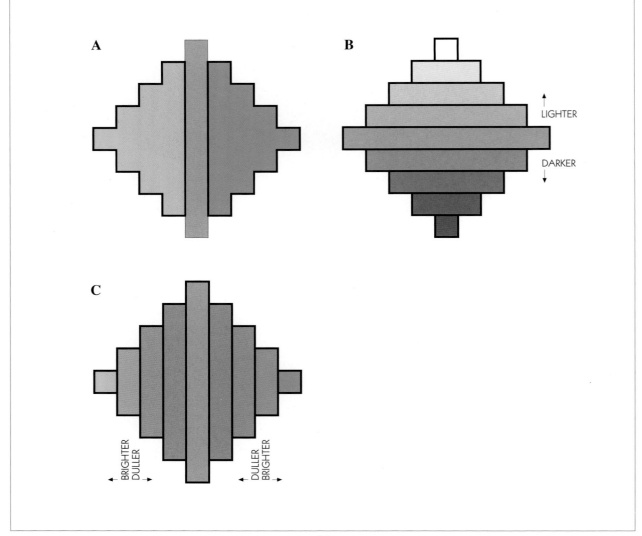

Yellow/Purple and Yellow-Orange/Blue-Purple Cross Sections

Red/Green and Red-Purple/Yellow-Green Cross Sections

HORIZONTAL CROSS SECTIONS OF THE COLOR SOLID

Color Variations for Each Value

Horizontal cross sections of the color solid show color variations for each value in relation to hue and chroma.

Hue: Changes in hue occur in a circular direction within each cross section

Value: Colors in each individual cross section are all the same value. Colors become progressively lighter toward the top of the color solid (upper left on this page), and progressively darker toward the bottom (lower right on this page).

Chroma: Colors farther from the center of each cross section become progressively brighter, while colors closer to the center of each cross section become progressively duller.

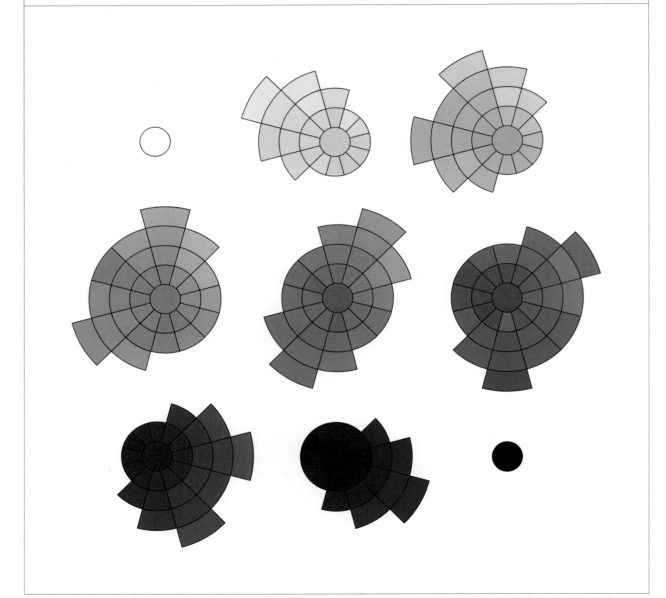

INTERRELATION OF THE PROPERTIES OF COLOR

Changing Individual Properties

The three properties of color (hue, value and chroma) work in relation to each other, as well as independently from each other. It is possible to change only one property, two properties, or all three properties of a color.

Examples in which only one property of color changes:

SAME HUE
SAME VALUE
DIFFERENT CHROMA

SAME HUE
DIFFERENT VALUE
SAME CHROMA

DIFFERENT HUE
SAME VALUE
SAME CHROMA

Examples in which only two properties of color change:

SAME HUE
DIFFERENT VALUE
DIFFERENT CHROMA

DIFFERENT HUE
SAME VALUE
DIFFERENT CHROMA

DIFFERENT HUE
DIFFERENT VALUE
SAME CHROMA

Example in which all three properties of color change:

DIFFERENT HUE
DIFFERENT VALUE
DIFFERENT CHROMA

Simple Color Changes

Simple color changes in hue (bluer, greener, etc.), value (lighter or darker), or chroma (brighter or duller) can be made by adding colors from a wide range of options.

Changing a color's hue.

To change the hue:
 Add a different hue, other than the original color's complement.

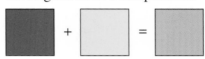

Changing a color's value.

To lighten the value:
 Add a lighter color of any hue.

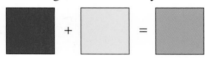

Add a lighter gray or white.

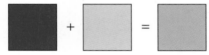

To darken the value:
 Add a darker color of any hue.

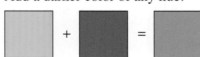

Add a darker gray or black.

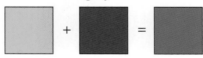

Changing a color's chroma.

To brighten the chroma:
 Add more of the original hue.

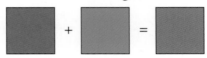

To dull the chroma:
 Add a duller color of any hue.

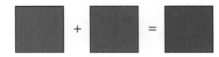

Add black, gray or white.

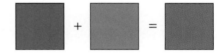

Add the complementary color.

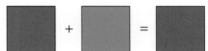

Complex Color Changes

More complex and specific color changes in hue, value and chroma can be made by adding colors from a more limited range of options.

Changing all three properties of a color.

To change hue, value and chroma:
 Add a color of a different hue, value and chroma.

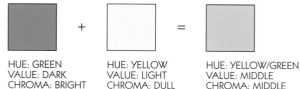

HUE: GREEN	HUE: YELLOW	HUE: YELLOW/GREEN
VALUE: DARK	VALUE: LIGHT	VALUE: MIDDLE
CHROMA: BRIGHT	CHROMA: DULL	CHROMA: MIDDLE

Changing two properties of a color.

To change hue and value only:
 Add a color of a different hue and value, but the same chroma as the original color.

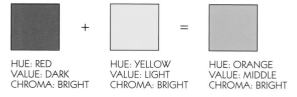

HUE: RED	HUE: YELLOW	HUE: ORANGE
VALUE: DARK	VALUE: LIGHT	VALUE: MIDDLE
CHROMA: BRIGHT	CHROMA: BRIGHT	CHROMA: BRIGHT

To change hue and chroma only:
 Add a color of a different hue and chroma, but the same value as the original color.

HUE: BLUE	HUE: GREEN	HUE: BLUE/GREEN
VALUE: DARK	VALUE: DARK	VALUE: DARK
CHROMA: BRIGHT	CHROMA: DULL	CHROMA: MIDDLE

To change value and chroma only:
 Add a color of a different value and chroma, but the same hue as the original color.

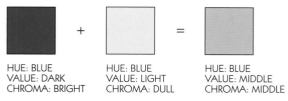

HUE: BLUE	HUE: BLUE	HUE: BLUE
VALUE: DARK	VALUE: LIGHT	VALUE: MIDDLE
CHROMA: BRIGHT	CHROMA: DULL	CHROMA: MIDDLE

Changing one property of a color.

To change hue only:
Add a color of a different hue, but the same value and chroma as the original color.

HUE: BLUE	HUE: GREEN	HUE: BLUE/GREEN
VALUE: MIDDLE	VALUE: MIDDLE	VALUE: MIDDLE
CHROMA: MIDDLE	CHROMA: MIDDLE	CHROMA: MIDDLE

To change value only:
Add a color of a different value, but the same hue and chroma as the original color.

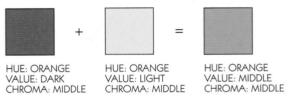

HUE: ORANGE	HUE: ORANGE	HUE: ORANGE
VALUE: DARK	VALUE: LIGHT	VALUE: MIDDLE
CHROMA: MIDDLE	CHROMA: MIDDLE	CHROMA: MIDDLE

To change chroma only:
Add a color of a different chroma, but the same hue and value as the original color.

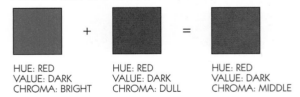

HUE: RED	HUE: RED	HUE: RED
VALUE: DARK	VALUE: DARK	VALUE: DARK
CHROMA: BRIGHT	CHROMA: DULL	CHROMA: MIDDLE

TEMPERATURE

Warm and Cool Colors

Temperature: The relative warmth or coolness in the appearance of a color.

The twelve hues on the color wheel can be divided into five different temperature levels, ranging from warm to cool.

1. Warm: Yellow, yellow-orange, orange, red-orange, red.
2. Relatively Warm: Yellow-green, red-purple.
3. Transitional: Green, purple.
4. Relatively Cool: Blue-green, blue-purple.
5. Cool: Blue.

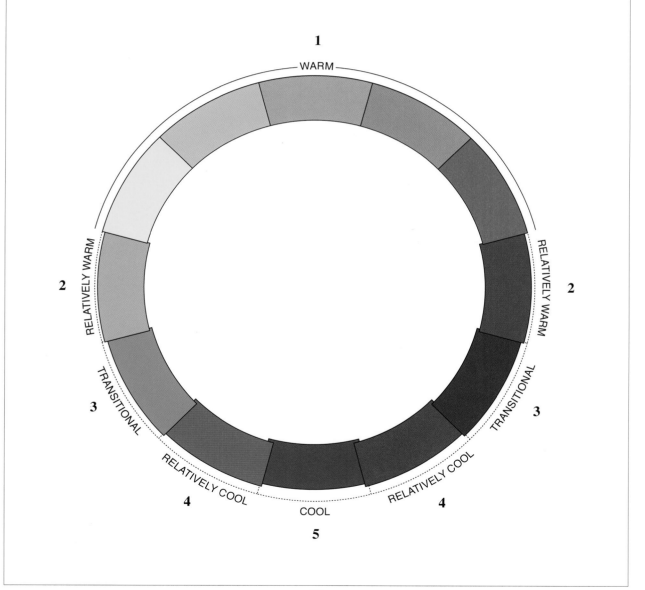

TEMPERATURE

Changing a Color's Temperature

Changes in color temperature can be made by adding a color from a different temperature level. To warm a color, add a color from a warmer temperature level. To cool a color, add a color from a cooler temperature level. The color will be warmed or cooled to a varying degree depending on which temperature level is added. The diagrams below show which colors can be used to warm (orange tint) or cool (blue tint) the basic colors of the color wheel.

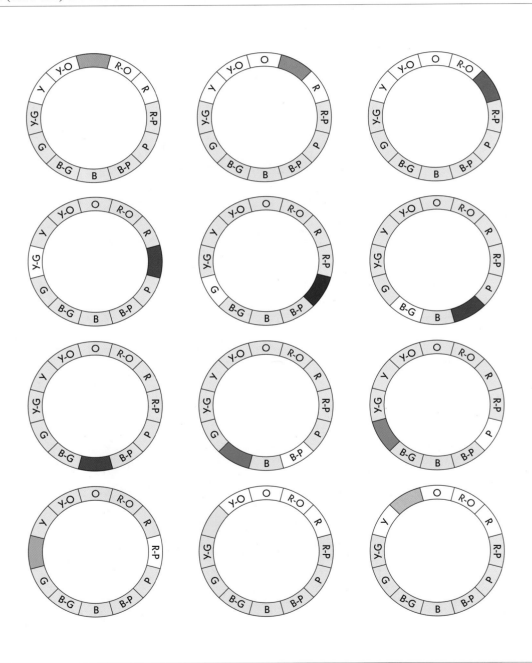

THE RULE OF SIMULTANEOUS CONTRAST

One Color Appearing as Two

The Rule of Simultaneous Contrast: When two colors come into direct contact, the contrast will intensify the differences between them.

When a dark color and a light color are tangent to each other, the dark color will appear darker in contrast to the light color, just as the light color will appear lighter in contrast to the dark color. The same contrasts will also occur with hue and chroma. In the examples below, the two circles in each horizontal row are the identical color.

Value:
Through value contrast between the circle and the square it is placed on, the gray circle appears darker on the left and lighter on the right.

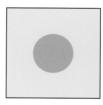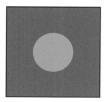

Value and hue:
Through value contrast between the circle and the square it is placed on, the orange circle appears darker on the left and lighter on the right. Through hue contrast between the circle and the square it is placed on, the orange circle appears redder on the left and yellower on the right.

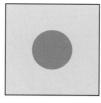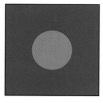

Value, hue and chroma:
Through value contrast between the circle and the square it is placed on, the blue-green circle appears darker on the left and lighter on the right. Through hue contrast between the circle and the square it is placed on, the blue-green circle appears bluer on the left and greener on the right. Through chroma contrast between the circle and the square it is placed on, the blue-green circle appears brighter on the left and duller on the right.

BASIC COLOR COMBINATIONS

Hue

Basic color combinations can serve as a starting point for beginning art students' color studies and compositions.

Achromatic: Using no color, a black and white value study. (Not shown)

Monochromatic: Using only one hue combined with black and white. (Not shown)

Analagous: Using any two or more adjacent hues on the color wheel combined with black and white.

Diad: Using any two hues that are two steps apart on the color wheel combined with black and white.

Complementary: Using any two opposite hues on the color wheel combined with black and white.

Split Complement: Using three hues, one hue and the hues on either side of its complement on the color wheel combined with black and white.

Triad: Using any three equally-spaced hues on the color wheel combined with black and white.

Tetrad: Using any four equally-spaced hues on the color wheel combined with black and white.

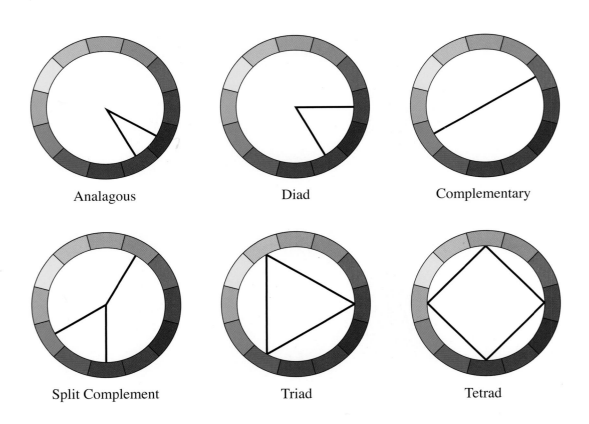

| Analagous | Diad | Complementary |

| Split Complement | Triad | Tetrad |

LIGHT & SHADE

INTRODUCTION

Definition: The term light and shade refers to light and dark areas in drawing and painting. Light and shade is used in representational work to define the form of the subject matter in the drawing or painting. The form is best described to the viewer by the artist's ability to accurately simulate volume on a two-dimensional surface. To create the illusion of a three-dimensional volume in a drawing or painting is not an easy task, since the paper or canvas the artist works on is flat. In order to accomplish this, the artist must understand the structure and the form of the subject matter, thereby drawing with brain and eye, not just the eye. In other words, it is necessary to draw what you know about the subject matter as well as what you see.

Conceptual Light Source: When most of us began making art as children, we copied photographs. Many adult art students still copy photographs value for value, and also copy scenes from life value for value. Lighting in photographs and in scenes from life often do not benefit the artist. If you create an accurate copy of a photograph or scene from life that has poor lighting, then your drawing will have poor lighting, and consequently, even with all your copying skills you will probably have a poor drawing. Many people have the ability to copy images well, but to become an artist one needs to be more than just a good copier. As an artist there is nothing wrong with working from photographs, but if you are still copying photographs or scenes from life value for value, then it is time for a more professional approach. An approach that will not only include the artist's hand and eye, but will also simultaneously include the artist's brain. Discussed in this chapter is the use of a conceptual light source which will aid in your working from photographs and also from life. The conceptual light source is represented on the following pages by the icon of the winged light bulb.

Images: The majority of objects used as examples in this chapter are the most basic of volumes: cubes, cylinders and spheres. An understanding of more complex objects can be achieved by visually breaking the objects apart into basic volumes. The drawings in this chapter are presented in a sketchy manner similar to the drawings I do in class while explaining concepts to individual students. The drawings are then given to the students for future reference.

TYPICAL LIGHTING

Value Contrast

Most lighting in photographs, as well as from life, is not very helpful to the artist. Lighting in a majority of settings tends to be fairly even with minimal value contrast, which results in visually flattened objects (1). A flash used in photographs tends to over-lighten objects in value which also diminishes value contrast and volume (2). Setting a spotlight on objects, which can be effective at times, tends to create extreme value contrast with very few middle tones, also giving an unrealistic representation of an object's form (3).

THE PREMISE OF A CONCEPTUAL LIGHT SOURCE

Application

Conceptual Light Source: A light source, visualized by the artist, from which a subject is shaded based on the angles of its planes.

The more a plane is angled away from the conceptual light source, the darker the plane will appear.

To begin, visualize a light source at approximately a 45-degree angle above and to one side of the object(s) being drawn. (Additional information about the location of the conceptual light source begins on page 96.) Whether working from a photograph or from life, be aware of each plane's angle in relation to the conceptual light source, and shade each plane accordingly. Planes angled more toward the light source will be lighter in value, while planes angled more away from the light source will be darker in value. Ignore the values that you see on the subject, whether you are working from a photograph or from life. By using a conceptual light source you will now have the ability to go beyond poor photographic lighting and poor natural lighting, the ability to create the illusion of volume on a two-dimensional surface, the ability to light a subject in your manner of choice, and no need to ever have to copy again. Once you are comfortable using a conceptual light source, a balance can then be established between the use of a conceptual light source and a more visual approach to a subject's value range.

91

LIGHT SOURCE

Cube

Shading: The dark or shaded areas on a drawn or painted object. (Not to be confused with shadow which is defined on page 114.)

The individual planes of a cube are shaded as flat (ungraduated) values because there are no angle changes within the individual planes. In essence, the planes are shaded as flat values because they are flat planes. The only changes in value on the cube itself occur from plane to plane because each plane is at a different angle.

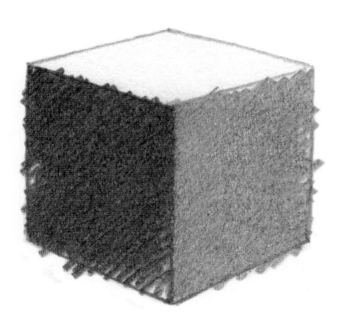

Octagon

The octagon, like the cube, consists of flat planes with each plane shaded as a flat value. The four outside planes (1-4) progress from a dark value on the left side of the octagon to a light value on the right side as they angle toward the conceptual light source. The four inside planes (1a-4a) progress from a light value on the left to a dark value on the right as they angle away from the conceptual light source. The far left outside plane (1) and the far right inside plane (1a) are both dark in value because they are angled away from the light source, and both are the same value as each other because they are at the same angle. Similarly, planes 4 and 4a are both light in value because they are angled toward the light source, and both are the same value as each other because they are at the same angle. Planes 2 and 2a and planes 3 and 3a follow the same pattern.

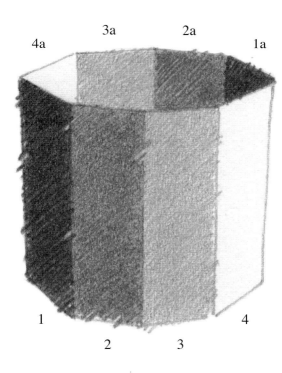

LIGHT SOURCE

Cylinder

The cylinder, like the octagon, will change in value from one side to the other as it angles toward the light source; but unlike the octagon, the value will continuously and smoothly change (a graduated change) since the surface is curved. Like the octagon, areas 1 and 1a are both dark in value because they are angled away from the light source, and both are the same value as each other because they are at the same angle. Areas 4 and 4a are both light in value because they are angled toward the light source, and both are the same value as each other because they are at the same angle. Areas 2 and 2a and areas 3 and 3a follow the same pattern.

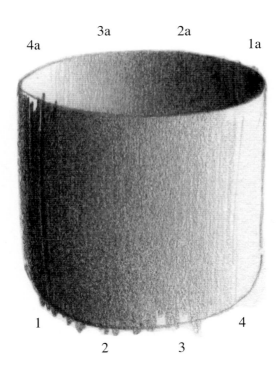

LIGHT SOURCE

Sphere

The sphere will continuously and smoothly change in value since the entire surface is curved. Like the cylinder, the sphere will change in value from the left side to the right side as it angles toward the light source. But unlike the cylinder, the sphere will also change in value from bottom to top as it angles toward the light source. Since the light source in this diagram is placed above and to the right of the object, the lightest part of the sphere will be the upper right area while the darkest part of the sphere will be the lower left area. A gradual (radial) blending of value occurs between the light and dark extremes.

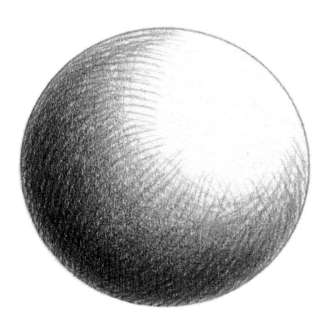

LIGHT SOURCE

Beginning Location

To create the maximum illusion of volume in a drawing or painting, it is recommended that beginning art students place the conceptual light source at approximately a 45-degree angle above and to one side of the object(s) being drawn. Placing the light source on either the right side of the object (diagram A) or the left side (diagram B) is the choice of the artist. To place the light source at any other location will generally minimize the illusion of volume.

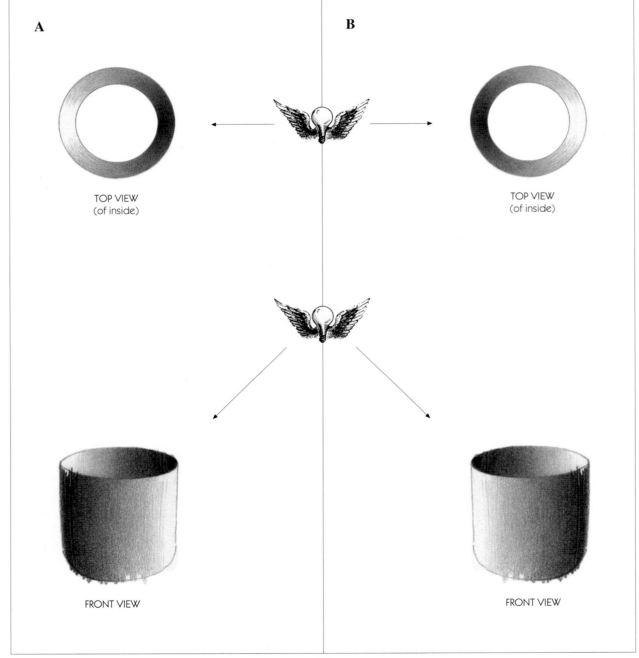

A

B

TOP VIEW
(of inside)

TOP VIEW
(of inside)

FRONT VIEW

FRONT VIEW

LIGHT SOURCE

Advanced Location

Once a student is comfortable using the conceptual light source, the light source can be placed at any location that pertains to the effect the artist wants to achieve. Multiple light sources with varying degrees of strength can also be used effectively.

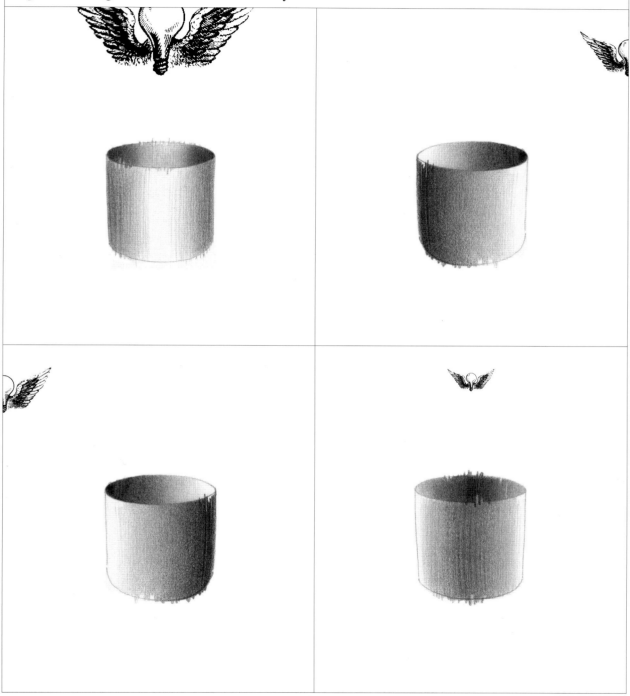

SHADING COMPARISON

Flat and Curved Planes

The object on the left has flat planes, the center object has slightly curved planes, and the object on the right has planes with more curve. The three planes on the left object (1, 4, 7) are shaded as flat values, the three planes on the center object (2, 5, 8) change value slightly, and the three planes on the right object (3, 6, 9) change value more. For best understanding the differences in value between the flat, slightly curved, and more curved planes, compare the series of similarly located planes on the three objects with each other: the three left planes (1, 2, 3), the three center planes (4, 5, 6), and the three right planes (7, 8, 9). As the planes in each series become more curved, each plane becomes lighter on the left and darker on the right in relation to its angle from the light source.

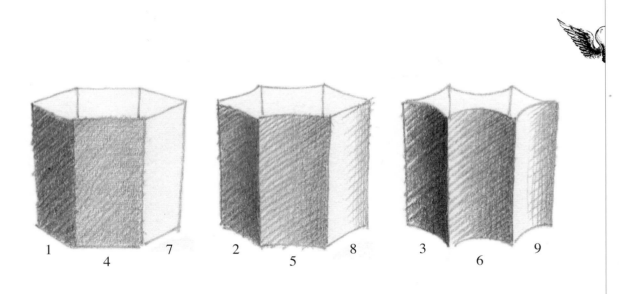

Cylinder and Cone

The dark sides of the three objects are slightly different in value from each other because of their differences in angle. The dark side of the cylinder (1) is the darkest of the three because it is angled more away from the light source; the dark side of the center object (2) is slightly lighter in value because it is angled more toward the light source, and the dark side of the cone (3) is the lightest of the three because it is angled the most toward the light source.

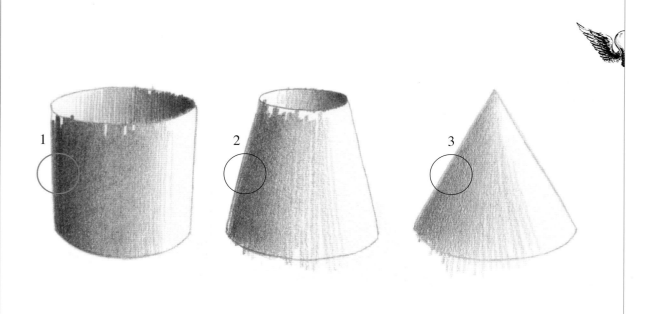

Cylinder and Two Cones

The dark sides of the three objects differ in value because of their differences in angle. In comparing the cylinder (1) with the top halves of the other two objects (2, 3), the cylinder is the darkest because it is angled more away from the light source. The top halves of the other two objects (2, 3) become respectively lighter in value as they angle toward the light source. In comparing the cylinder (1) with the bottom halves of the other two objects (4, 5), the cylinder is the lightest because it is angled more toward the light source. The bottom halves of the other two objects (4, 5) become respectively darker in value as they angle more away from the light source.

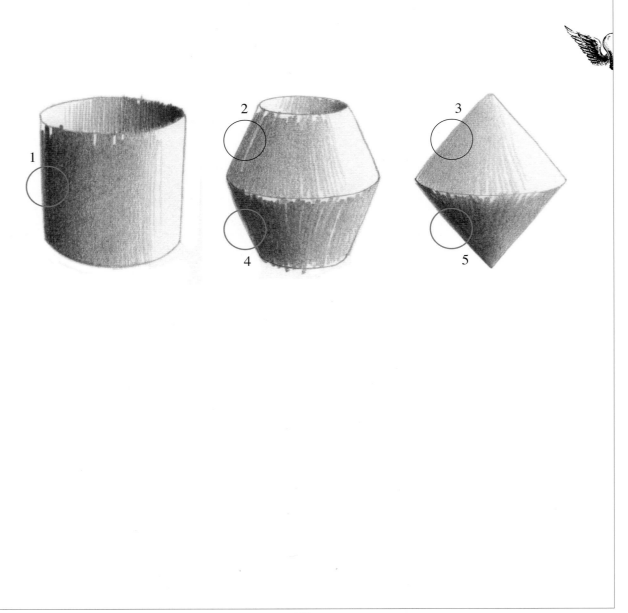

Cylinder and Sphere

The dark sides of the three objects differ in value because of their differences in angle. In comparing the cylinder (1) with the top halves of the center object and the sphere (2, 3), the cylinder is the darkest because it is angled more away from the light source. The top halves of the other two objects (2, 3) become respectively lighter in value as they angle toward the light source. In comparing the cylinder (1) with the bottom halves of the center object and the sphere (4, 5), the cylinder is the lightest because it is angled more toward the light source. The bottom halves of the other two objects (4, 5) become respectively darker in value as they angle more away from the light source.

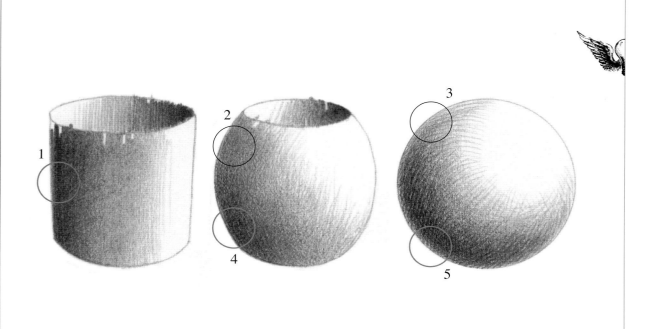

DISTANCE FROM THE LIGHT SOURCE

Value Range

When shading flat planes, beginning students frequently shade parts of individual planes in relation to their distance from the light source (diagram A;1,2). While this thinking is not necessarily incorrect, it gives the viewer a confusing message as to whether a plane is flat or curved. Consequently, it is recommended that distance from the light source not be considered within individual planes, only the plane's angle (diagram B). Consideration of entire objects is a different matter. Objects farther from the light source can appear darker overall than will objects closer to the light source (diagram C).

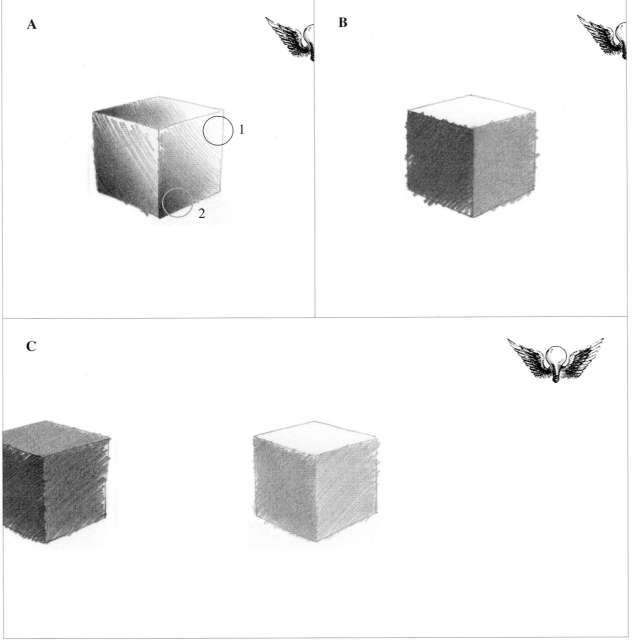

LOCAL VALUE

Single-Valued Objects

Local Value: One value of an object that is most characteristic of that object. (Example: lemon, light local value; plum, dark local value.)

Objects with a light local value will have a lighter overall value range (diagram A), while objects with a dark local value will have a darker overall value range (diagram B).

A

 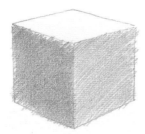 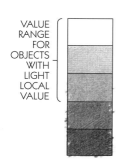

VALUE
RANGE
FOR
OBJECTS
WITH
LIGHT
LOCAL
VALUE

B

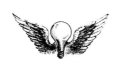

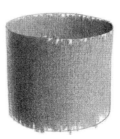 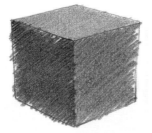 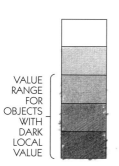

VALUE
RANGE
FOR
OBJECTS
WITH
DARK
LOCAL
VALUE

LOCAL VALUE

Multi-valued Objects

Value Ratio: Equal differences (or jumps) in value between two or more pairs of values.

A multi-valued object will combine the value range of an object with a light local value as well as the value range of an object with a dark local value (diagram A). The two value ranges should be kept in value ratio to each other, i.e., the differences (or jumps) in value between the two shades on each plane should be equal (diagram B). The jumps in value on all three value scales are equal; therefore all three pairs of values are in value ratio. The two objects in diagram C illustrate the result of combining the light and dark local value ranges on each object, as well as keeping the values on each plane in value ratio. The planes are numbered in relation to their corresponding value scales.

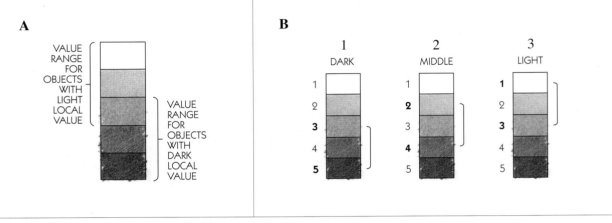

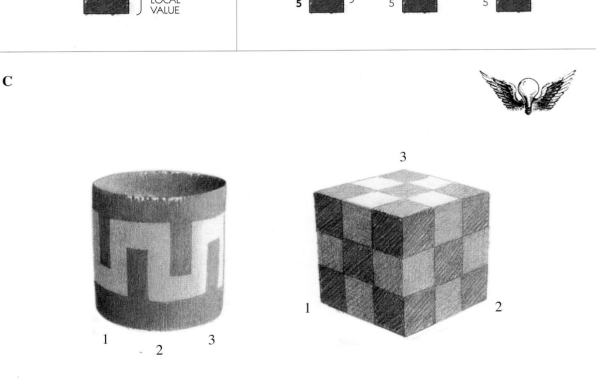

DETAIL

Cubes

Detail or surface coloration should be kept relatively close in value to the area on which it is located, and should be kept in value ratio on each plane (diagram A).

Use of strong value contrast within an object's individual planes will tend to flatten the object (diagram B). It is recommended to use strong value contrast only for the value differences between the individual planes, and thereby enhance the object's overall volume.

A

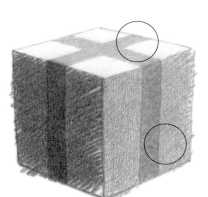

B

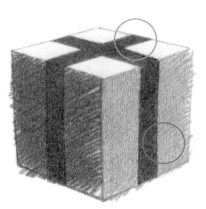

Cylinders

Detail or surface coloration on a curved surface should be kept relatively close in value to the area on which it is located, and also kept in value ratio (diagram A). Use of strong value contrast within an object's individual areas will tend to flatten the object (diagram B).

A

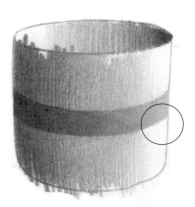

B

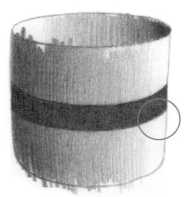

REFLECTED LIGHT

Cylinders

Reflected Light: A slight lightening in value on the dark edge of a curved surface.

The use of reflected light on a curved surface confirms the illusion that the object completes 360°

Reflected light is a visual cue that implies the same value range seen on the front half of the object is beginning to be repeated (in reverse direction) on the back half (diagram A). Without the use of reflected light (diagram B), the viewer is less convinced the object completes 360°

A

TOP VIEW

B

TOP VIEW

Spheres

The slight lightening in value on the dark edge of the sphere (diagram A), is a visual cue that implies the same value range seen on the front half of the object is beginning to be repeated (in reverse direction) on the back half. Without the use of reflected light (diagram B), the viewer is less convinced the object is a sphere and not a hemisphere.

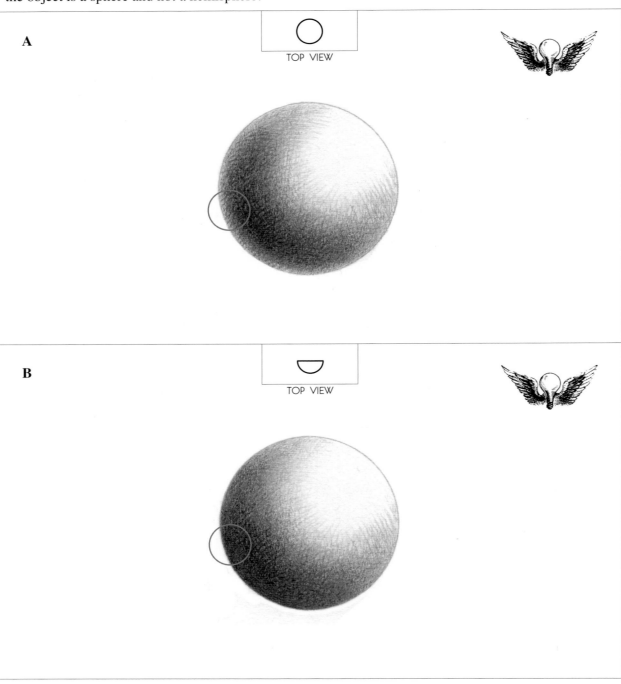

A

TOP VIEW

B

TOP VIEW

MULTI-ANGLED OBJECTS

Value Changes

Shading a multi-angled object is best accomplished by visually breaking the object into basic forms and shading each one separately (1). When the object is visually reassembled, the dark and light shaded areas will frequently change sides on the object, sometimes suddenly due to a sharp angle change (2), and sometimes gradually due to more subtle angle changes (3,4).

1

2

3

4

ECONOMY

Value Range

Economy: The use of less shading by the artist.

A drawing that uses economy, one that is not shaded in completely (diagram A), will have more value contrast and thereby a greater illusion of volume, will show more confidence from the artist having done more with less, and will take less time to complete. A drawing without economy will have the opposite effect (diagram B).

A

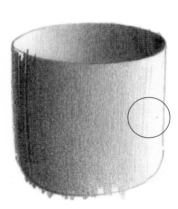

B

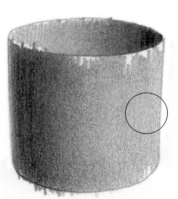

DIRECTION

Cubes

As a general (but not definitive) rule, the direction of drawn lines should follow the form of the object. On a cube's flat surfaces, straight lines of any angle are recommended.

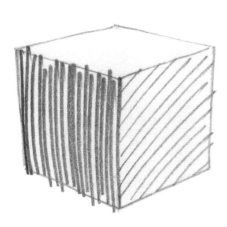

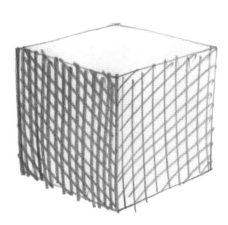

Cylinders

On a cylinder's flat (vertical) and curved (horizontal) surface, straight vertical lines and/or curved horizontal lines are recommended.

Spheres

On a sphere's complex curved surface, any combination of long curved lines, short curved lines or short straight lines is recommended.

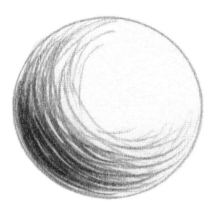

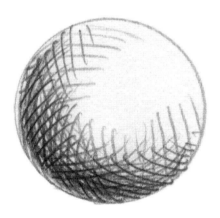

SHADOWS

Value and Edge

Shadow: A dark area cast by an object onto the ground plane or onto another object.

Depending on the distance from the object, a shadow will vary in both value and precision of edge. The part of the shadow tangent to the object will appear darker in value and with a more precise edge (1), while farther from the object, a shadow will gradually appear lighter in value and with a more blurred edge (2).

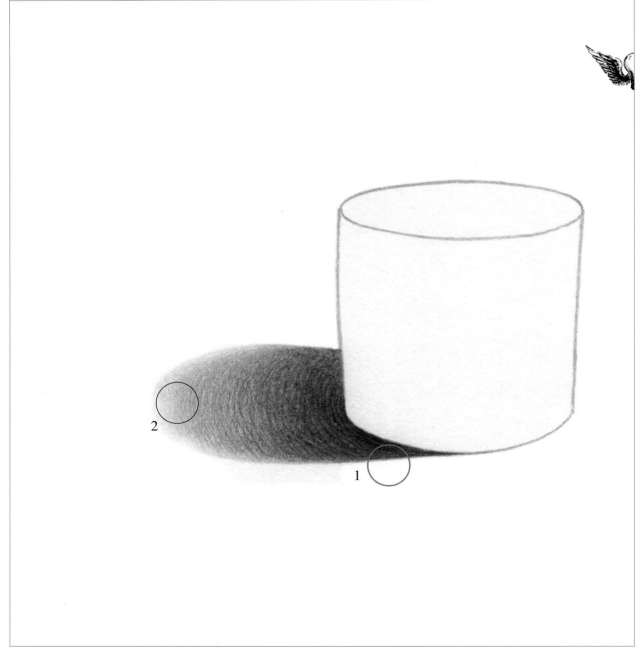

Configuration

A shadow will be darkest in value where it is tangent to the object from which it is cast (diagrams A and B, areas 1). Diagram A illustrates a top view of shadows cast by both cube and cylinder. Area 2 in that diagram, the part of the shadow to the right of the vertical dotted line, will not be visible in the front views of the cube and cylinder in diagram B. A common mistake many beginning students make is to draw or paint area 3 (diagram B) - where it appears to be tangent to the object but is actually not - as dark as area 1. Since area 3 is not tangent to the object, it will be lighter in value than area 1.

A

TOP VIEWS

B

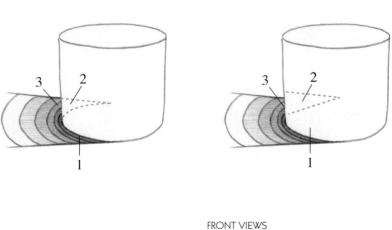

FRONT VIEWS

Value Relation to Shade

It is recommended that the part of the shadow tangent to the object be either lighter than (1) or darker than (2), but not the same value as, the shading on the object tangent to the shadow. Having those tangential areas be the same value as each other will tend to decrease the illusion of volume.

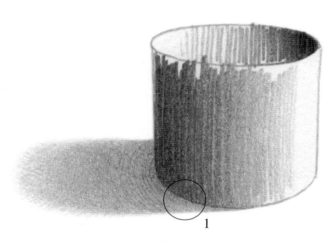

1

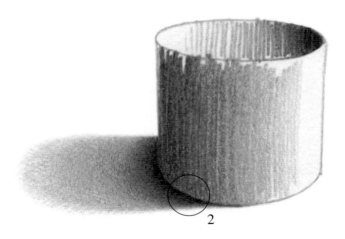

2

Sequence

Most beginning art students add shading and shadows to their drawings simultaneously, which frequently leads to their confusion and to the distortion of form. To alleviate this problem, it is recommended that all planes be shaded as though no other objects or parts of objects are blocking the light source; i.e., shade each plane as though it is the only plane on the entire page. Once all planes have been shaded in this manner (diagram A), then add the shadows (diagram B). In essence, think of the shading as the object's structure or primary values, and the shadows as the object's surface coloration or secondary values.

A

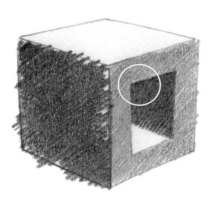

B

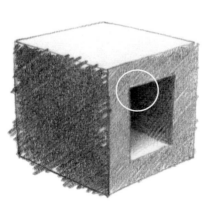

Separating Planes of Similar Angle

Separating planes of similar angle (diagram A) is best accomplished by casting a shadow from one plane onto the other plane (diagram B).

A

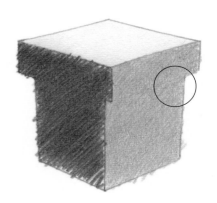

B

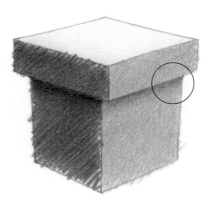

Exterior versus Interior Shadows

Exterior Shadow: A shadow cast by an object onto a ground plane (1), or onto another object that serves as a ground plane (2).

Interior Shadow: A shadow cast by part of an object onto itself (3), or by one object onto another (4).

Exterior shadows are most effective in adding to an object's form if strong value contrast is used (1,2). Interior shadows are most effective in not destroying an object's form if minimal value contrast is used (3,4).

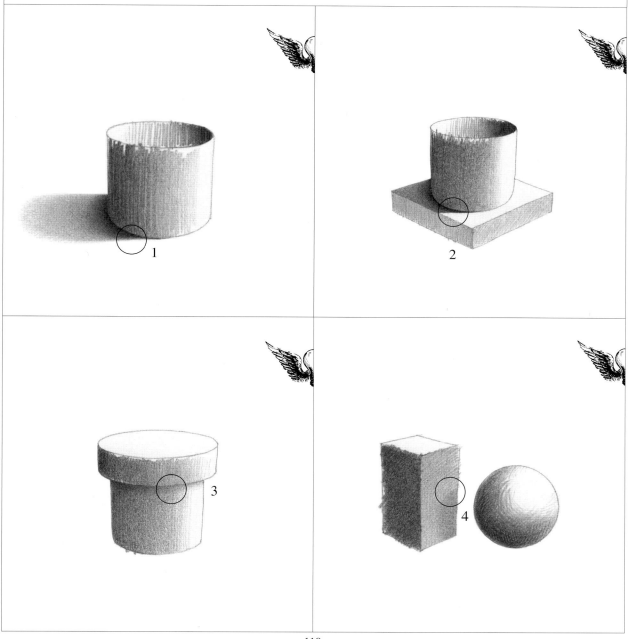

Casting Shadows on Other Objects

A shadow will follow the form of an object on which it is cast.

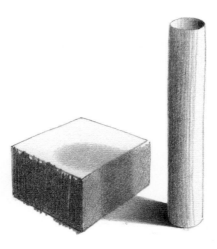

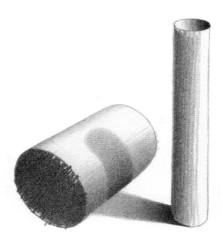

SHADOWS

Multi-valued Surfaces

A shadow will change in value ratio to the multi-valued surface on which it is cast.

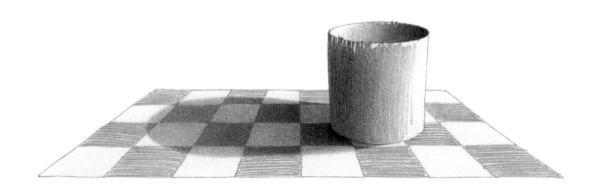

SHADOWS

Elevated Objects

The more an object is elevated above the ground plane, the more its shadow will be enlarged, lightened in value, and blurred.

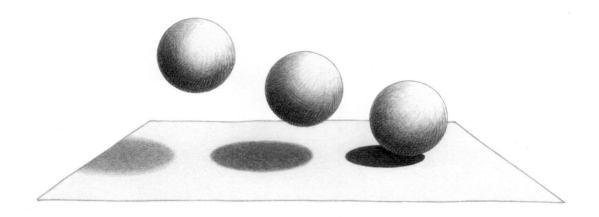

AMBIGUOUS VOLUME

Intentional and Unintentional

Ambiguous Volume: The illusion of volume in which objects appear to have dual forms. Can be created intentionally or unintentionally.

The theories of light and shade can be used intentionally to contradict each other for the purpose of creating ambiguous volume, which in itself is an effective element in both representational and non-representational works. However, if your intent is to create an illusion of logical form, the contradiction of light and shade theories will have a negative impact on that effect. Below are four of innumerable possible examples of ambiguous volume utilizing theory contradictions.

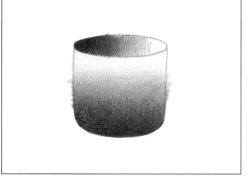

According to the shape, the object is a cylinder with a horizontally curved surface; but according to the shading, the front of the object has a vertically curved surface.

According to the shape, the object is flat; but according to the shading, the object is curved.

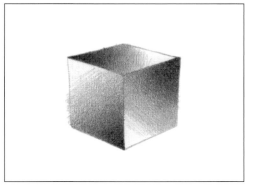

According to the shape, the object is a cube with three visible flat planes; but according to the shading, the three planes are curved.

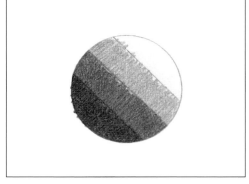

According to the shape, the object is either a flat circle or a sphere; but according to the shading, the object has four flat planes, each at a different angle.

ATMOSPHERIC PERSPECTIVE

INTRODUCTION

Definition: As with linear perspective, atmospheric perspective (a.k.a. aerial perspective) is a means to create the illusion of depth on a two-dimensional surface. In essence this is accomplished by drawing or painting the effect of the atmosphere (fog, haze, pollution, etc.) on objects as they recede in space. Unlike linear perspective - which concerns the angles of lines and the shapes of areas - atmospheric perspective concerns the object's size, position and focus; but more importantly, it concerns the object's color (hue, value and chroma). Creating the illusion of depth on a flat surface (drawing paper or canvas) is not an easy thing for the artist to accomplish. Because the viewer knows the drawn or painted surface is in reality flat, the artist has a major challenge to convince the viewer otherwise. This, however, can be accomplished by incorporating the theories presented in this chapter. The four major ways to create the illusion of depth are through hue (temperature), chroma, value (object-background contrast), and value (object contrast) and are discussed on pages 129, 130, 131-133, and 134 respectively.

Non-Representational Imagery: A common misunderstanding among art students is that the basic theories of drawing and painting pertain only to representational imagery. Fundamental theory pertains to non-representational imagery as well. An example of this: Since value changes in a drawing or color changes in a painting will create some illusion of depth, it is necessary for the artist working abstractly or non-objectively to understand the theories of atmospheric perspective so as to be able to control the value and color changes for their desired spatial effect, whether it be deep space, shallow space, or no space at all.

THE PREMISE OF ATMOSPHERIC PERSPECTIVE

Illusion of Depth

All colors are affected by the atmosphere as they recede in space. The farther away an object is in space, the more atmosphere the viewer will be looking through to see that object. Consequently, the farther away an object is in space, the more the object's color will resemble the color of the atmosphere. In drawing and painting, when the artist intends to create the illusion of depth, the chosen background color is the color of the atmosphere, and therefore all objects will need to become more similar in color to the background color as they are depicted receding in space.

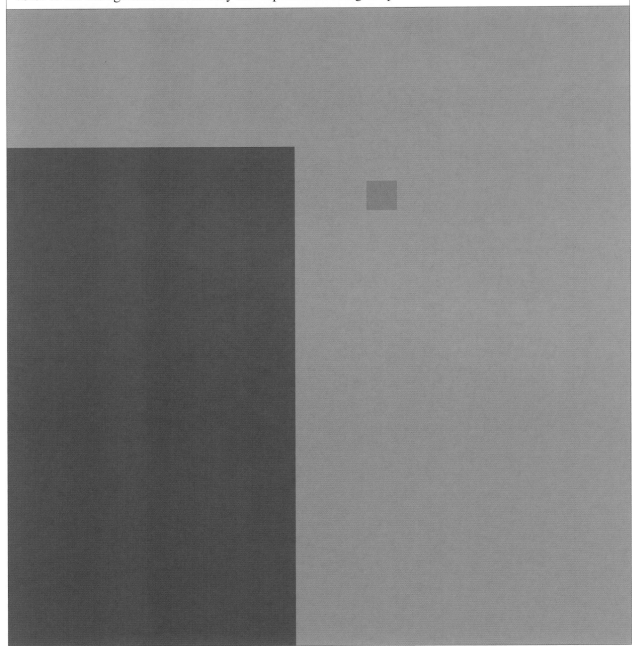

GENERAL USE OF COLOR

Diminishing Color Options

Color options diminish in hue, value and chroma as objects recede in space.

To create the illusion of depth, a full hue (temperature) range, a full value range, and a full chroma range can all be used in the foreground, but limited hue (temperature), value and chroma ranges will be necessary for use in the background. These diagrams give an overall view of the concept of diminishing color options used to create the illusion of depth. Specific options for hue, value and chroma are explained on the following pages.

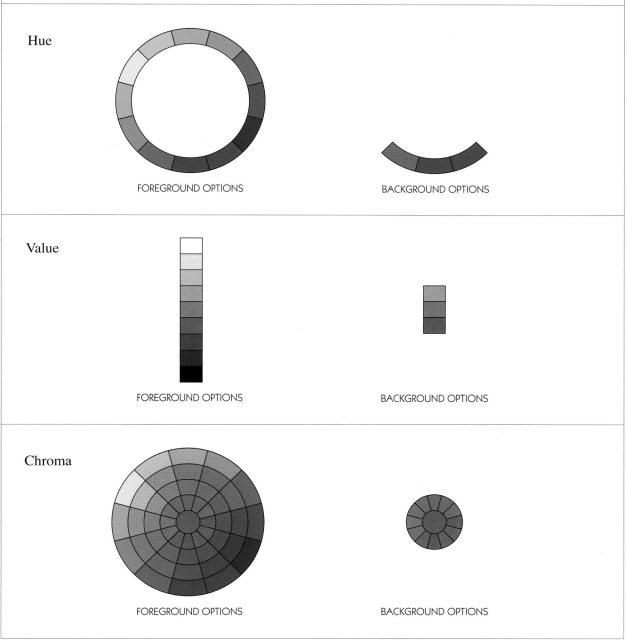

Hue

FOREGROUND OPTIONS BACKGROUND OPTIONS

Value

FOREGROUND OPTIONS BACKGROUND OPTIONS

Chroma

FOREGROUND OPTIONS BACKGROUND OPTIONS

Continued

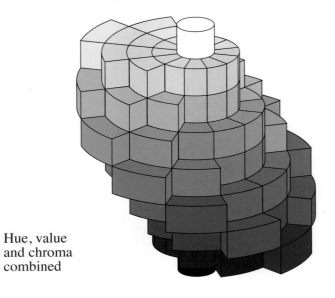

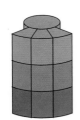

Hue, value
and chroma
combined

FOREGROUND OPTIONS

BACKGROUND OPTIONS

Hue, value
and chroma
combined
(180°
view)

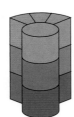

FOREGROUND OPTIONS

BACKGROUND OPTIONS

HUE (TEMPERATURE)

Warm to Cool

The warmer the color, the closer to the viewer it will appear.

In the upper diagram, the red square (1) will appear closer than will the other two squares or the background, since the red square is the warmest of the four colors. The red-purple square (2) will appear to be the next closest to the viewer; the blue-purple square (3) to be farther back, and the blue background to be the farthest back in space since it is the coolest of the four colors. In essence, objects will appear cooler as they recede in space. The lower diagram illustrates how the location of colors on the color wheel affects their temperature; as colors approach blue, they become cooler, see page 83.

For the sake of clarity, only the hue changes in these diagrams, not the value or chroma.

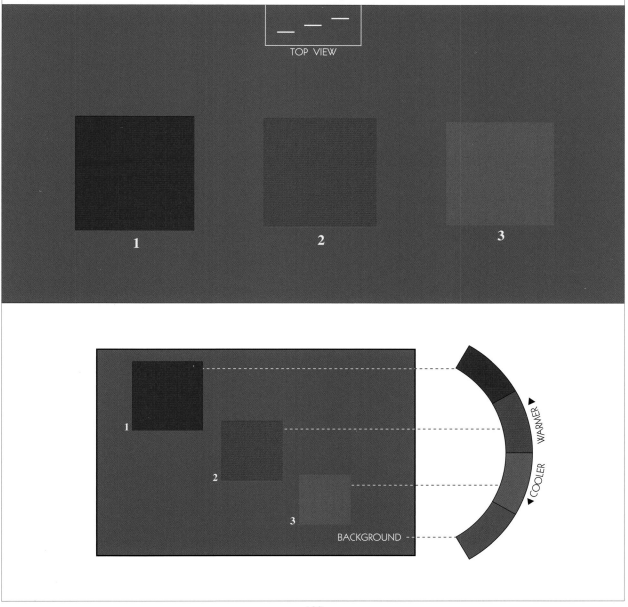

129

CHROMA

Bright to Dull

The brighter the color, the closer to the viewer it will appear.

In the upper diagram, the left square (1) will appear closer than will the other two squares or the background, since the left square is the brightest of the four colors. The middle square (2) will appear to be the next closest to the viewer; the right square (3) to be farther back, and the background to be the farthest back in space since it is the dullest of the four colors. In essence, objects will appear duller as they recede in space. The lower diagram illustrates the location of the colors on a chroma scale.

For the sake of clarity, only the chroma changes in these diagrams, not the hue or value.

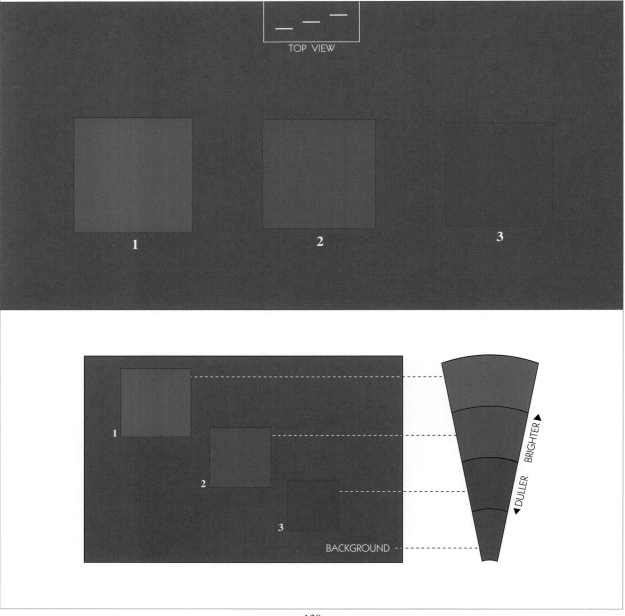

VALUE (OBJECT-BACKGROUND CONTRAST)

Light Background

Object-Background Contrast: The value contrast between an object and the background.

The greater the value contrast between object and background, the closer to the viewer the object will appear.

In the upper diagram, the black square will appear closer than will the other two squares due to the strong value contrast between it and the background. The light gray square will appear to be the farthest from the viewer due to the minimal value contrast between it and the background. In essence, objects will appear closer in value to the background as they recede in space; on a light background they will become lighter in value. The lower diagram illustrates the location of the values on the value scale.

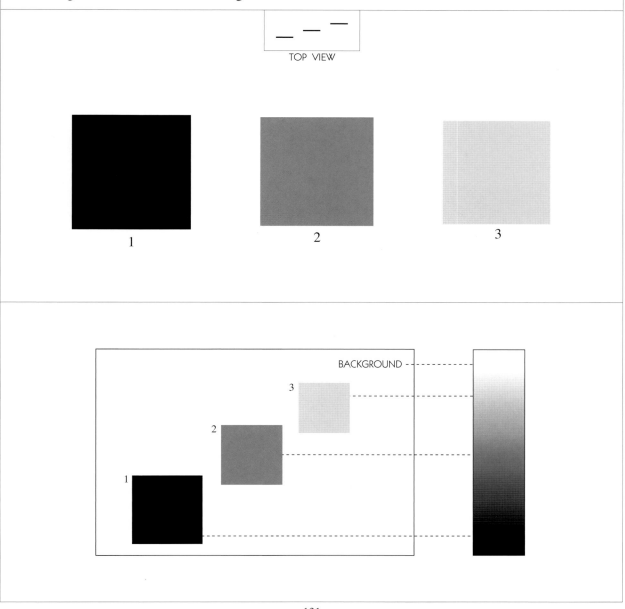

VALUE (OBJECT-BACKGROUND CONTRAST)

Dark Background

In the upper diagram, the white square will appear closer to the viewer than will the other two squares due to the strong value contrast between it and the background. The dark gray square will appear to be the farthest due to the minimal value contrast between it and the background. In essence, objects will appear closer in value to the background as they recede in space; on a dark background they will become darker in value. The lower diagram illustrates the location of the values on a value scale.

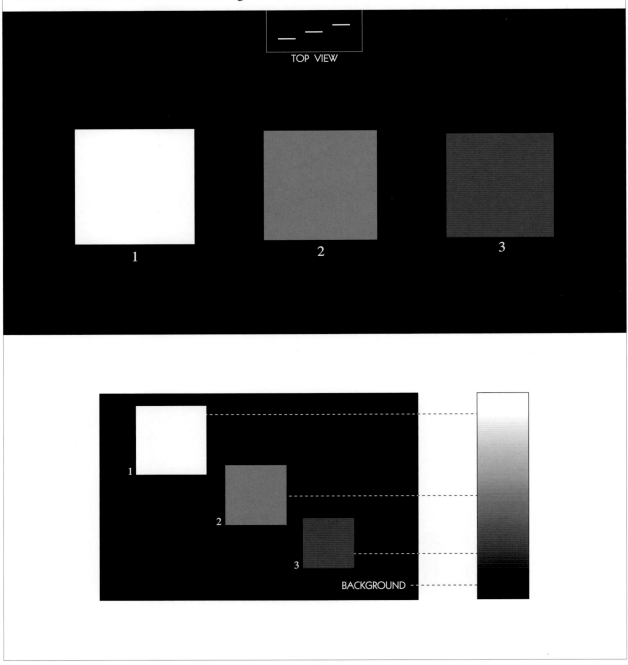

Middle Value Background

In the upper diagram, both the black and white rectangles will appear closer to the viewer than will the other four rectangles due to the strong value contrast between the two of them and the background. The two rectangles on the far right will appear to be the farthest from the viewer due to the minimal value contrast between each of them and the background. In essence, objects will appear closer in value to the background as they recede in space; on a middle value background they will become more middle value. The lower diagram illustrates the location of the values on a value scale.

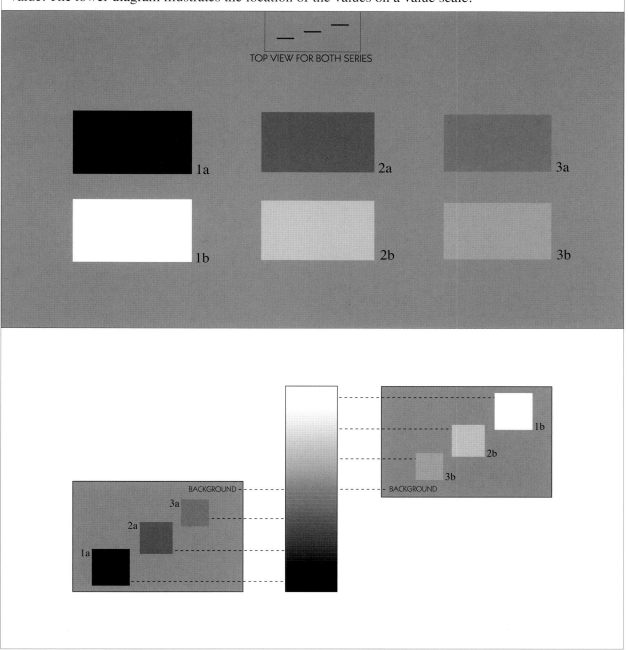

133

VALUE (OBJECT CONTRAST)

More Contrast to Less Contrast

Object Contrast: The value contrast within an object.

The greater the value contrast within an object, the closer to the viewer the object will appear.

In the upper diagram, the cube on the left will appear closer than will the other two cubes due to the strong value contrast between its three planes. The cube on the right will appear to be the farthest from the viewer due to the minimal value contrast between its three planes. In essence, all parts of an object will appear closer in value to each other as the object recedes in space. The lower diagram illustrates how the choice of values diminishes as objects recede.

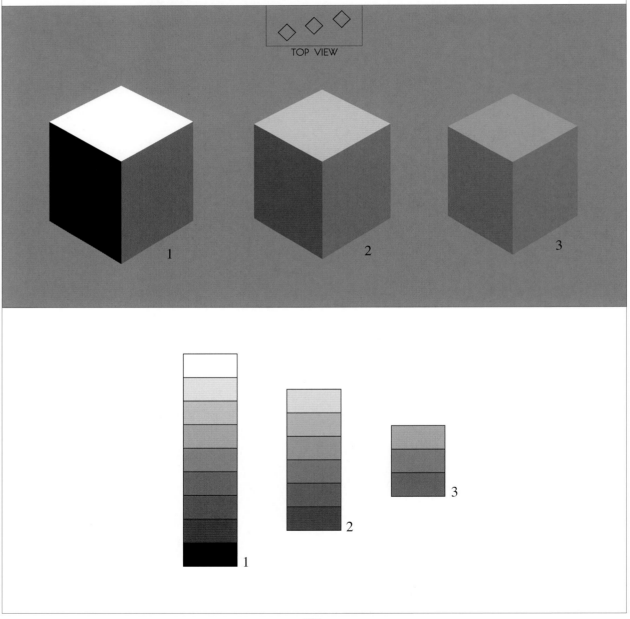

134

SIMULTANEOUS USE OF VALUE THEORIES

Light Background

The next three pages illustrate the simultaneous use of the Object-Background Contrast and Object Contrast theories for a greater spatial effect. In the upper diagram, the left cube will appear closer to the viewer than will the other two cubes due to the strong value contrast between it and the background, and also due to the strong value contrast between its three planes. The right cube will appear to be the farthest due to the minimal value contrast between it and the background, and also due to the minimal value contrast between its three planes. In essence, objects will appear closer in value to the background, and all parts of an object will appear closer in value to each other as the object recedes in space. The lower diagram illustrates how the choice of values diminishes toward the background, in this case a light value, as objects recede.

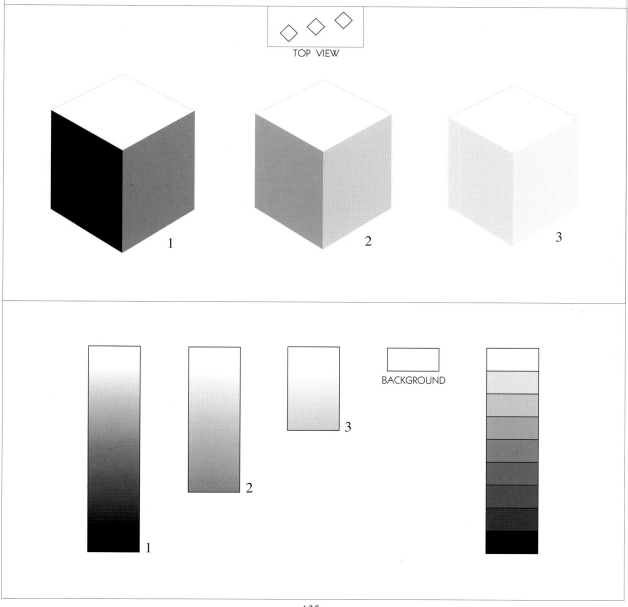

135

Middle Value Background

In the upper diagram, the left cube will appear closer to the viewer than will the other two cubes due to the strong value contrast between it and the background, and also due to the strong value contrast between its three planes. The right cube will appear to be the farthest due to the minimal value contrast between it and the background, and also due to the minimal value contrast between its three planes. In essence, objects will appear closer in value to the background, and all parts of an object will appear closer in value to each other as the object recedes in space. The lower diagram illustrates how the choice of values diminishes toward the background, in this case a middle value, as objects recede.

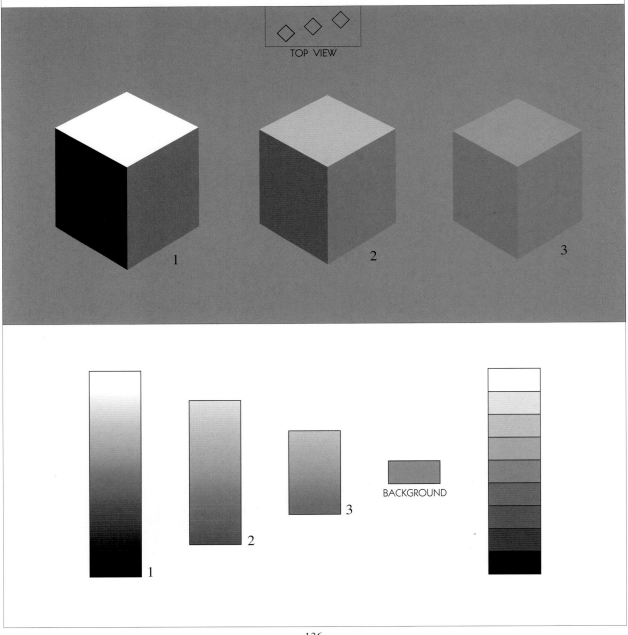

Dark Background

In the upper diagram, the left cube will appear closer to the viewer than will the other two cubes due to the strong value contrast between it and the background, and also due to the strong value contrast between its three planes. The right cube will appear to be the farthest due to the minimal value contrast between it and the background, and also due to the minimal value contrast between its three planes. In essence, objects will appear closer in value to the background, and all parts of an object will appear closer in value to each other as the object recedes in space. The lower diagram illustrates how the choice of values diminishes toward the background, in this case a dark value, as objects recede.

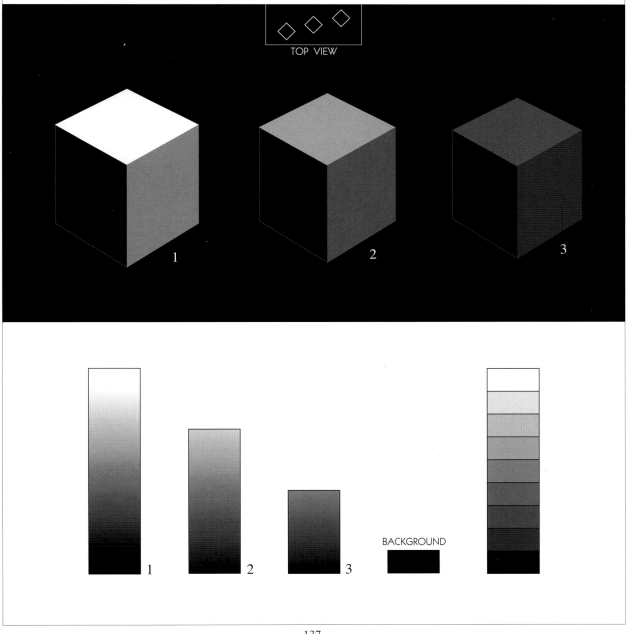

Value Limitations

Another way of understanding the concept of the simultaneous use of the two value theories is to consider the individual planes of the cubes as three separate series (diagram A). Think of the three left planes of each cube as one series (1a, 2a, 3a), the three right planes as a second series (1b, 2b, 3b), and the three top planes as a third series (1c, 2c, 3c). Since all values will become closer in value to the background as they recede in space, once the values of the foreground object and the value of the background have been established (diagram B), the values of the other planes will fall within those established value limitations (diagram C).

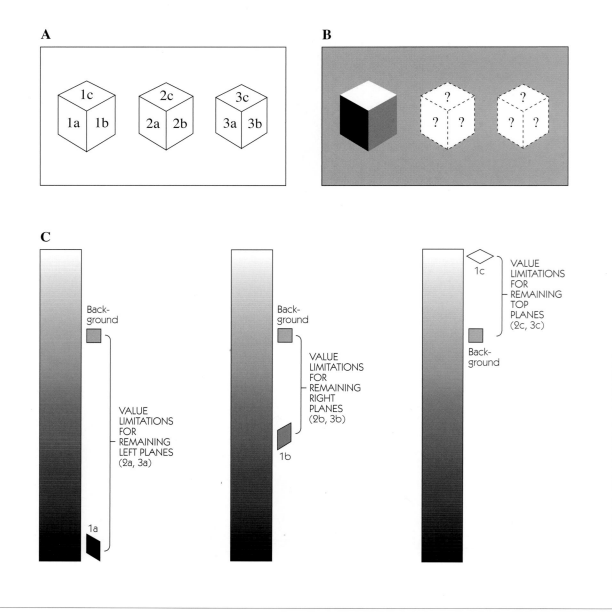

Continued

Diagram D shows the value locations for the remaining planes on the value scale. Note how the three individual series of planes (left, right and top) form value scales in themselves. Diagram E illustrates the result.

D

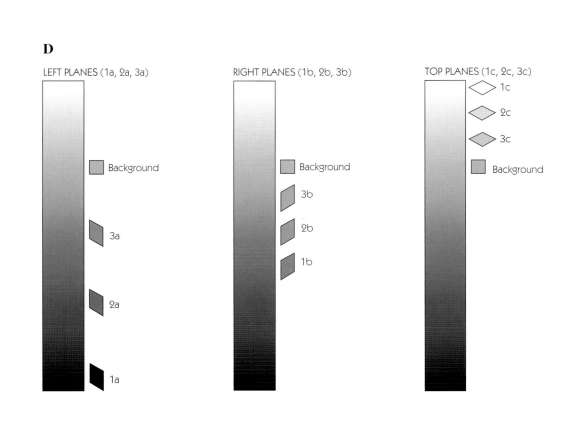

E

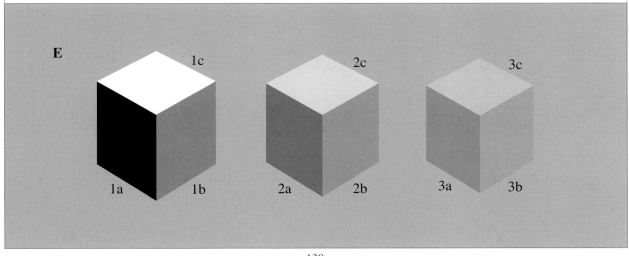

ADDITIONAL SPATIAL INDICATORS

Size

Since objects appear smaller as they recede in space, in general larger objects will appear closer to the viewer than will smaller objects.

TOP VIEW

Overlap

An object overlapping another object will appear closer to the viewer than will the overlapped object.

Comparing this diagram with the previous diagram is an example of how theories can contradict each other. The smallest object in the previous diagram, which according to that theory was the farthest from the viewer, is in this diagram the closest to the viewer. For additional information on theory contradictions, see page 152.

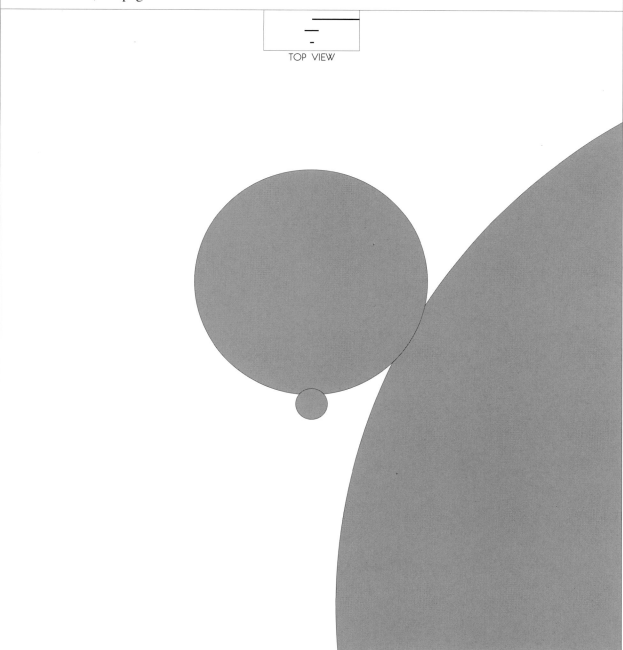

TOP VIEW

Vertical Location

Objects lower on the picture plane will appear closer to the viewer than will objects of similar size which are higher on the picture plane, diagram A.

This is due to a visual association with objects or scenes that we view in everyday life, the majority of which we view below our eye level. When objects are viewed below eye level, the objects lower on the picture plane will be the ones that are actually closer to the viewer, diagram B, object 2.

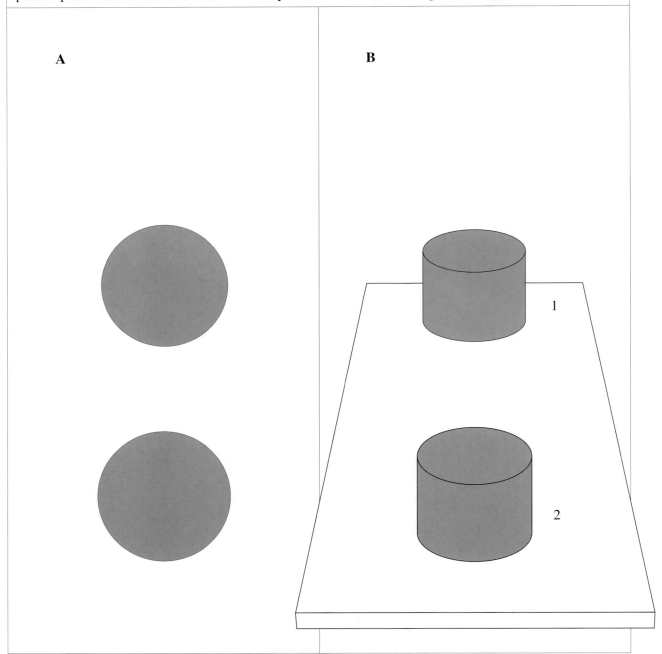

A

B

1

2

Center/Edge Location

Objects near to or cropped by the picture edge will appear closer to the viewer than will objects of similar size which are nearer the picture plane's center.

This is due to a visual association with the picture edge or frame as being tangible and within our reach, and thereby appearing closer to us than drawn or painted images nearer the center.

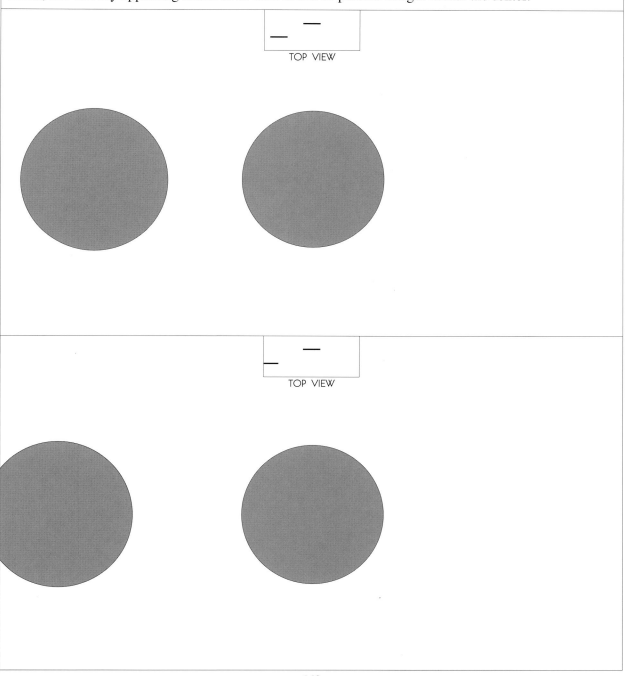

TOP VIEW

TOP VIEW

Focus

The greater the degree of focus change between objects, the greater is the implied depth or distance between them.

When a viewer focuses on an object in the foreground (diagram A, object 1), objects will appear increasingly less focused or less detailed as they recede in space (diagram A, objects 2 & 3). Conversely, when a viewer focuses on an object in the background (diagram B, object 3), objects will appear increasingly less focused or less detailed as they approach the viewer (diagram B, objects 2 & 1).

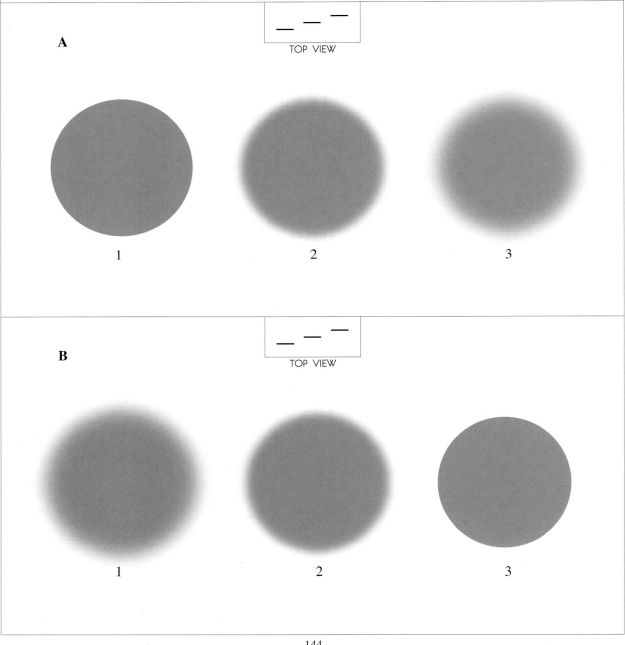

ACCUMULATIVE RESULT

Additional Spatial Indicators

The following pages illustrate the accumulative result of adding one theory per diagram to create the illusion of depth. The first diagram shows two cubes equidistant from the viewer. The second diagram begins to imply depth through Size (page 140), the third diagram through Overlap (page 141), and the fourth diagram through Location (pages 142 and 143). The objects' colors have yet to change, but will on the following pages.

Size

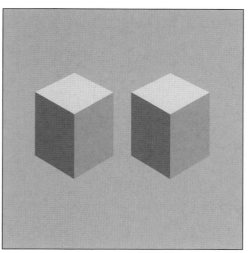
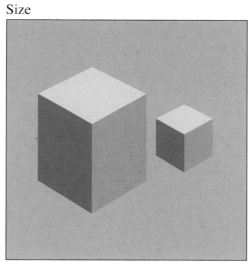

Overlap

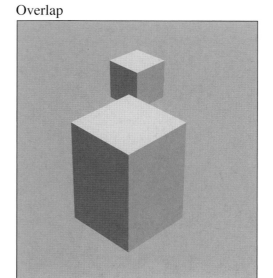

Location

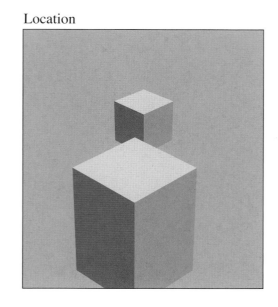

Value (Object-Background Contrast)

Value contrast between the two objects is increased by darkening the foreground object and by making the background object's overall value more similar to the value of the background. See pages 131, 132 and 133.

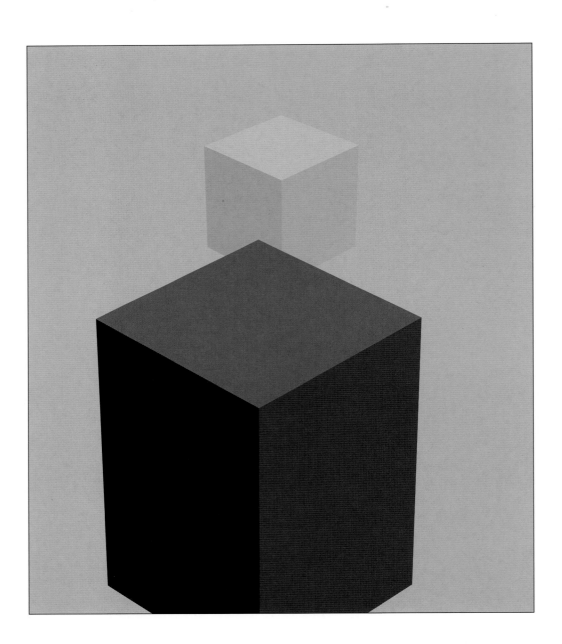

Value (Object Contrast)

Value contrast within the foreground object is increased by adding a full value range (light, middle, and dark values) to the three planes of the cube. See page 134.

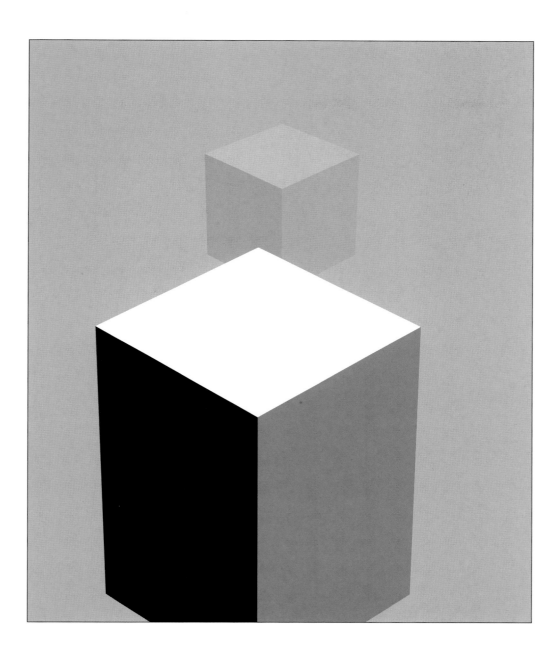

Chroma

Chroma change is created by adding color to the two objects, with more intense colors added to the foreground object and less intense colors added to the background object. See page 130.

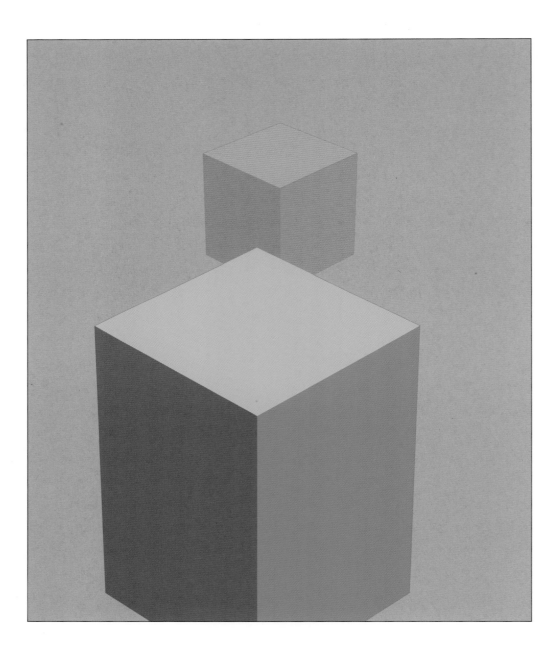

Hue (Temperature)

Temperature change is created by adding a cooler color to the background object and to the background. Blue is added to the background object's three planes, and a greater amount of blue to the background. See page 129.

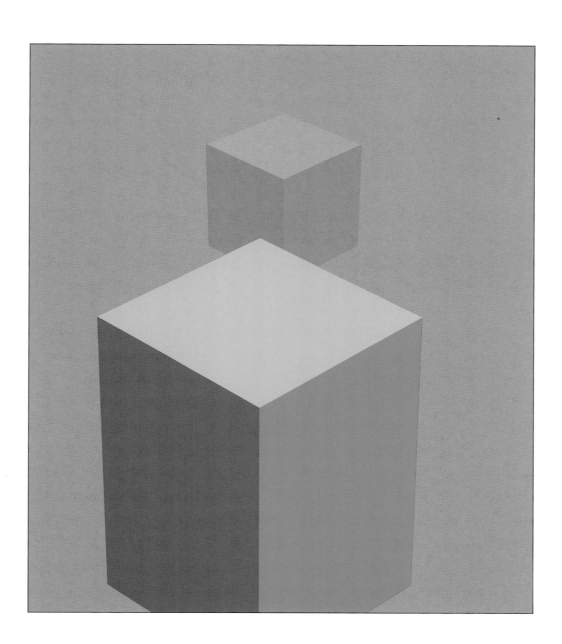

Focus

Focus contrast is created between the two objects by blurring the background object. See page 144.

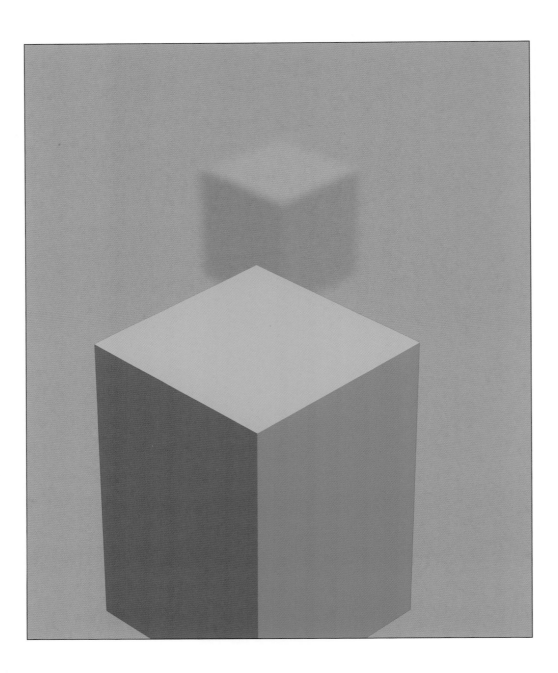

Summary

Size

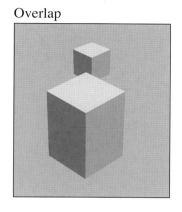

Overlap

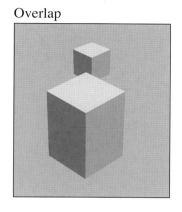

Location

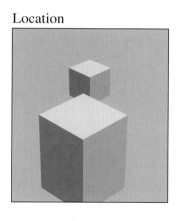

Value (Object-Background Contrast)

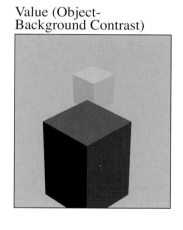

Value (Object Contrast)

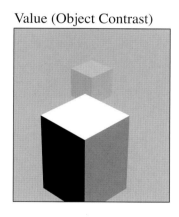

Chroma

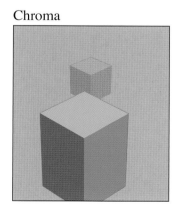

Hue (Temperature)

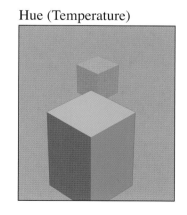

Focus

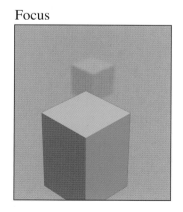

SPATIAL AMBIGUITY
Intentional and Unintentional

Spatial Ambiguity: The illusion of depth in which certain objects or shapes appear to have dual locations in space. Can be created intentionally or unintentionally.

The theories of atmospheric perspective can be used intentionally to contradict each other for the purpose of creating spatial ambiguity, which in itself is an effective element in both representational and non-representational works. However, if your intent is to create an illusion of logical depth, the contradiction of atmospheric perspective theories will have a negative impact on that spatial effect. Below are four of innumerable possible examples of spatial ambiguity utilizing theory contradictions.

According to Value (Object-Background Contrast), the black circle appears closer to the viewer; but according to Size, the gray circle appears closer to the viewer.

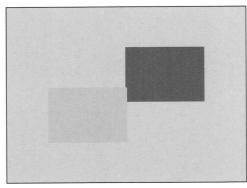

According to Overlap, the blue rectangle appears closer to the viewer; but according to Hue (Temperature) and Chroma, the red rectangle appears closer to the viewer.

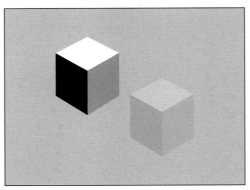

According to Value (Object-Background Contrast) and Value (Object Contrast), the left cube appears closer to the viewer; but according to Vertical Location, the right cube appears closer to the viewer.

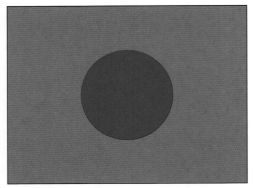

According to Chroma, the blue circle appears closer to the viewer; but according to Hue (Temperature), the orange plane, with a circular window, appears closer to the viewer.

GLOSSARY

achromatic Basic color combination using no color; a black and white value study.

aerial perspective See atmospheric perspective.

ambiguous volume The illusion of volume in which objects appear to have dual forms. Can be created intentionally or unwittingly.

analogous Basic color combination using any two or more adjacent hues on the color wheel combined with black and white.

angled cube A cube in which all planes are foreshortened to the viewer.

atmospheric perspective A means to create the illusion of depth on a two-dimensional surface with a major emphasis on color changes.

background Refers to objects, areas, or a back wall that appear far from the viewer due to the illusion of depth in a drawing or painting.

bright Refers to a characteristic of chroma.

center/edge location Refers to an object's proximity to the picture edge.

conceptual light source A light source, visualized by the artist, from which a subject is shaded based on the angles of its planes.

chroma One of the three properties of color; the brightness or dullness of a color.

chroma scale A gradation of two complementary hues from bright to dull to bright, with colors of full-intensity at both ends of the scale and a neutral in the middle.

color solid A three-dimensional representation of variations in hue, value and chroma.

color wheel A representation of variations in hue at full intensity.

complementary Basic color combination using any two opposite hues on the color wheel combined with black and white.

complementary colors, complements Any two diametrically opposite colors on the color wheel.

cool Refers to a characteristic of temperature. The main cool color is blue.

crop A cropped object is one that extends beyond the picture edge.

curvilinear perspective See four-point perspective.

dark Refers to a characteristic of value.

diad Basic color combination using any two hues that are two steps apart on the color wheel combined with black and white.

direction Refers to the angle and shape of drawn lines.

dull Refers to a characteristic of chroma.

economy The use of less shading by the artist.

exterior shadow A shadow cast by an object onto a ground plane, or onto another object that serves as a ground plane.

eye level The point from which an artist or observer views objects.

focus Refers to the degree of sharpness or blurriness of an object in relation to its location in space.

foreground Refers to objects or areas that appear to be close to the viewer due to the illusion of depth in a drawing or painting.

foreshortening A foreshortened plane or object is one that recedes in space, i.e., part of the plane or object is closer to the viewer than other parts of the plane or object.

form (As it pertains to representational drawing and painting), the simulated volume of an object.

four-point perspective A linear perspective system in which a rectangular object extends above and below, as well as to the right and left of, the viewer's planes of vision. A fourth vanishing point is required to complete the illusion. Also called curvilinear perspective.

frontal A view of a plane from head-on in which all parts of the plane are the same distance from the viewer.

frontal cube A cube in which one of the planes is viewed from head-on, i.e., the plane is a square or rectangle.

full intensity A color is at full intensity if it is as bright as possible, i.e., the colors on the color wheel.

gray See neutral.

ground plane Horizontal plane on which objects are located; floor, table, etc.

horizontal distance The distance of an object from the viewer along a horizontal plane; the distance of an object off in space.

horizontal plane of vision An imaginary plane that extends horizontally from the viewer's eye level.

hue One of the three properties of color, the quality of a color (the redness, the blueness, etc.) that designates its name as well as its position on the color wheel.

intensity See chroma.

interior shadow A shadow cast by part of an object onto itself, or by one object onto another.

intermediate See tertiary.

isometric perspective Linear perspective system which utilizes no vanishing points; lines are drawn parallel to each other.

light Refers to a characteristic of value, and also to the light-valued areas on an object.

light source Illumination used to light a subject for drawing and painting. Can be natural, artificial or conceptual.

linear perspective The means to create the illusion of depth and the angle of viewing on a two-dimensional surface. It allows the artist to inform the viewer where an object is located in space and from what angle an object is viewed.

local color One color of an object that is most characteristic of that object.

local value One value of an object that is most characteristic of that object.

major axis The longest possible measurement within a symmetrical, geometric shape.

middle chroma The color halfway between full-intensity and neutral on the chroma scale.

middle value The color halfway between black and white on the value scale.

monochromatic Basic color combination using only one hue combined with black and white.

neutral A color that has no intensity; a pure gray.

object-background contrast The value contrast between an object and the background.

object contrast The value contrast within an object.

overlap Refers to one object covering or blocking from view part of another object in relation to their locations in space.

picture edge The physical edge of a drawing or painting.

picture plane The physical surface that is a drawing or painting, the paper or canvas.

planes of vision Two imaginary planes, horizontal and vertical, that extend from the viewer's eye level.

primary colors Red, yellow, and blue, all colors on the color wheel can be made by mixing different ratios of the primary colors.

properties of color The three parts of color: hue, value and chroma, the three ways to identify or to change a color.

reflected light A slight lightening in value on the dark edge of a curved surface.

rule of simultaneous contrast When two colors come into direct contact, the contrast will intensify the differences between them.

saturation See chroma.

secondary colors Green, purple, and orange, can be made by mixing equal parts of two primary colors.

shade A color made darker in value by adding black; also refers to the dark valued areas on an object.

shading The dark or shaded areas on a drawn or painted object.

shadow A dark area cast by an object onto the ground plane or onto another object.

size Refers to the dimension of an object in relation to its location in space.

spatial ambiguity The illusion of depth in which certain objects or shapes appear to have dual locations in space. Can be created intentionally or unwittingly.

split complement Basic color combination using three hues, one hue and the hues on either side of its complement on the color wheel combined with black and white.

temperature The relative warmth or coolness in the appearance of a color.

tertiary colors Red-orange, yellow-orange, yellow-green, blue-green, blue-purple, and red-purple; can be made by mixing equal parts of a

primary color and an adjacent secondary color.

tetrad Basic color combination using any four equally-spaced hues on the color wheel combined with black and white.

three-point perspective A linear perspective system in which the edges of a rectangular object recede to three vanishing points.

tint A color made lighter in value by adding white.

triad Basic color combination using any three equally-spaced hues on the color wheel combined with black and white.

two-point perspective A linear perspective system in which the horizontal edges of a rectangular object recede to two vanishing points, the vertical edges are drawn parallel to each other.

value One of the three properties of color, the lightness or darkness of a color.

value contrast Refers to dissimilarity between values.

value ratio Equal differences (or jumps) in value between two or more pairs of values.

value scale A gradation of grays (neutrals) from light to dark, with white at one end of the scale and black at the other end.

vanishing point (VP) A point in space where parallel lines appear to converge.

vertical distance The distance of an object above or below a viewer's eye level.

vertical location Refers to an object being higher or lower on the picture plane.

vertical plane of vision An imaginary plane that extends vertically from the viewer's eye-level.

warm Refers to a characteristic of temperature. The main warm colors are red, red-orange, orange, yellow-orange, and yellow.

INDEX

INDEX